T0125349

CHESTER ART

A SUBJECT LIST OF EXTANT AND LOST ART
INCLUDING ITEMS RELEVANT TO EARLY DRAMA

By *Sally-Beth MacLean*

Early Drama, Art, and Music,
Reference Series, 3

MEDIEVAL INSTITUTE PUBLICATIONS
Western Michigan University
Kalamazoo, Michigan
1982

Copyright 1982 by the Board of the Medieval Institute

ISBN 0-918720-20-6 (Hardbound)

ISBN 0-918720-21-4 (Paper)

Printed in the United States of America

ACKNOWLEDGMENTS

This book appears in a reference series designed to provide
students of iconography and early drama with subject lists of
related medieval and renaissance art in England and in some
major locations on the continent. The first published subject
list, *York Art,* has been used as a model throughout, although
the relative brevity of the Chester list has allowed me to
stray beyond the normal confines of the series to include the
few tomb effigies which survive in the city. A couple of these
effigies are significant for anyone interested in costume of
this period and in one case the armor is stylistically linked
with that of knights carved on the Cathedral misericords.

Although I lived for three years near Chester and developed
an abiding interest and love for the city at that time, the re-
search for *Chester Art* was undertaken after my return to Canada.
For this reason, I have been especially dependent upon the kind-
ness of several people who live in Chester and were willing to
give long-distance aid. My chief debt of gratitude is to Brian
Harris, editor of the Victoria County History volumes on Chesh-
ire. Dr. Harris took most of the photographs used in this book,
as well as many others which served as a visual basis for de-
scriptions in the list. He was an entertaining and learned
guide during my tour of Chester churches several years ago and
has been a long-suffering correspondent since that time, despite
his own busy schedule. My thanks also go to Annette Kennett,
City Archivist, for her prompt attention to my requests and
friendly welcome to the Chester City Record Office; to Denys
Doxat-Pratt who has given freely of his time and checked several
items *in situ* when I could not; and to Fred Harrison who pro-
vided several photographs from the churches of St. John, St.
Peter, and St. Mary-on-the-Hill.

Alexandra Johnston, general editor of the Records of Early
English Drama, originally proposed the Chester project to me.
Since that time, Clifford Davidson, the executive editor of
Early Drama, Art, and Music, has been a constant source of en-
couragement, and I am grateful for his discerning editorial eye
and many constructive suggestions. I am also indebted to David
O'Connor of the University of Manchester who recently examined
the painted glass of the church of St. Mary-on-the-Hill and made
a number of improvements to my descriptions.

Permission to publish photographs has been courteously
given by Dean Cleasby of Chester Cathedral; Mrs. Greta Fox,
Director of St. Mary's Centre, Cheshire County Council; the
Reverend R. S. Lunt, rector of Chester; Canon Maurice H. Ridg-

way and the Courtauld Institute of Art (for the photograph of the
St. Mary's pulpit panel taken by the late F. Crossley); and the
Bodleian Library, Oxford. I would also like to thank Brian Red-
wood, County Archivist, for allowing me to quote from manuscripts
in the Cheshire Record Office. I was fortunate in obtaining
reproductions of antiquarian sketches or photographs from the
printed collections of the Boston Public Library, Massachusetts,
and the Metropolitan Reference Library, Toronto.

Although I have attempted as complete a subject list as
possible within the EDAM guidelines, I am aware that readers,
especially in Chester, may find additions or corrections to
make. I will gladly receive any suggested improvements or no-
tice of lost works rediscovered.

SALLY-BETH MacLEAN
Toronto, 1982

CONTENTS

ILLUSTRATIONS

Plates

Map (inside back cover)

PHOTOGRAPHIC ACKNOWLEDGMENTS

*Photographs not otherwise identified in the
above list of figures and plates were taken
by Brian Harris. The map, which is repro-
duced by the courtesy of the Universiteits-
Bibliotheek, Amsterdam, was retouched by
Clair Dunn.*

INTRODUCTION

Research into narrative or subject art of medieval and ren-
aissance Chester is restricted for a variety of reasons. Al-
though the city is fortunate in the near-complete preservation
of its Whitsun play cycle, it has suffered severe losses in ar-
tistic representations of the biblical or hagiographical sto-
ries which were common sources of inspiration for both art and
drama in the period. Political and religious iconoclasm, inev-
itable decay to the friable local sandstone used as building ma-
terial, and alterations made by over-zealous nineteenth-century
restorers have all contributed to the destruction of painted
glass and carvings in stone or wood. Yet while Chester is not
as rich in surviving subject-art as a city like York, for exam-
ple, it has more items of interest than is often presumed, as
the list in this book should testify.

Historical Background

Knowledge of the production of drama in Chester comes pri-
marily from antiquarian writers of the sixteenth and seventeenth
centuries. Tradition ascribed the origin of the cycle plays to
the mayoralty of John Arnewaye in the early fourteenth century,
but the earliest contemporary information to survive on the sub-
ject is in a 1422 document from the Coopers' papers which re-
cords a guild dispute over the production of the pageants of the
Flagellation and *Crucifixion* in the play then performed on Cor-
pus Christi day.[1] In contrast, most of the medieval subject-art
remaining in Chester today predates the dramatic documentation:
seals and a manuscript illumination of the Crucifixion date from
the late twelfth century; the roof bosses of the Lady Chapel are
mid-thirteenth century; and the wealth of carvings in the Cathe-
dral choir are late fourteenth century.

The development and survival of medieval art in Chester
were inevitably tied to the fortunes of the local parish
churches and the Benedictine abbey of St. Werburgh. There were
nine parish churches in Chester: Holy and Undivided Trinity,
St. Bridget, St. John, St. Martin, St. Mary-on-the-Hill, St. Mi-
chael, St. Olave, St. Oswald, and St. Peter. Of the nine, two
have been demolished--St. Bridget in 1828 and St. Martin, ruin-
ous by 1721 but rebuilt and then finally pulled down in 1964.
The small church of St. Olave had a history of poverty and al-
though it was restored in the 1850's and stands today, it has
nothing of value for this iconographical study. St. Oswald's

1

parish had two locations for worship: from the fourteenth to early sixteenth centuries, the chapel of St. Nicholas which later became the Theatre Royal and Music Hall, and from the early sixteenth century to 1881, the south transept of the Cathedral (formerly abbey) church. Both locations have undergone extensive renovation over the years, and the south transept of the Cathedral, unlike some other sections of the building, has been cleared of any medieval art.

The remaining five churches all merit closer attention. Holy Trinity, at the corner of Watergate and Trinity streets, no longer functions as a church, but serves as Guildhall for the city. The building was greatly altered over the centuries and more or less rebuilt under the direction of the architect James Harrison in the mid-nineteenth century. A fourteenth-century effigy of some importance endured the years of restoration and has been recorded and photographed by nineteenth- and early twentieth-century antiquarians.[2] Its location, sadly, is now unknown; in the past it alternated between display in the nave and obscurity beneath the pew flooring, and it may well have been reburied some time during this century.[3] A detailed impression of the effigy and its military costume can be gleaned, however, from a variety of sources, including an early sketch by a member of the well-known Randle Holme family of antiquaries.[4] A sixteenth-century palimpsest brass showing the left leg of a knight of the Garter is still on display in the Guildhall but is not included in the subject list.[5]

The church of St. John, off Vicar's Lane, makes a potent impression on visitors because of its well-preserved Norman nave. Its prestige came early; its traditional founding date was 689, and for twenty-seven years, between 1075 and 1102, St. John's was the cathedral church of the diocese of Lichfield.[6] There was much building activity between the twelfth and fourteenth centuries when St. John's was a collegiate church, but finances were inadequate to maintain the fabric properly after the mid-fourteenth century.[7] Roof bosses exist from the fourteenth-century chapel roofs, but the Lady and choir chapels are now ruins in a garden setting. The worn sandstone bosses themselves are kept within the chapter house remains, an area restricted and not easily accessible to the public. Nineteenth-century restoration altered the exterior of the church but did little to change the nave, where three fourteenth-century tomb effigies can still be seen. The wall painting of the patron saint, John the Baptist, was probably retouched at this time and is therefore difficult to date beyond a probable fourteenth-century origin.

Apart from the Abbey, the parish church of St. Mary-on-the-Hill near the Castle had the richest endowment in medieval times.[8] Although the church was founded in the late twelfth century, its architecture is Perpendicular, reflecting fifteenth-century building activity in Chester which led to the reconstruction of many of the parish churches.[9] St. Mary's was also restored by James Harrison in the 1860's, but unlike the Cathedral, where restoration brought with it obliteration to some of the medieval fabric, some of the early glass was preserved and wall paintings were freed from their whitewash covering. In addition, some handsome Jacobean effigies of church benefactors remain in the St. Catherine Chapel on the north side, although the contents of the richly decorated chapel of the Troutbeck family, erected in 1433, were destroyed when the chapel fell down in 1661. St. Mary's was declared redundant in 1972 and is now used for an educational resources center by the County Council. Some of the church furnishings were given to other churches or sold at that time, and among items dispersed was the carved pulpit referred to in sixteenth-century churchwardens' accounts. Efforts to trace the pulpit have proved fruitless, but a photograph of one panel (Christ in Majesty) held by the National Monuments Record in London is fortunately still available.

St. Michael's Church, at the corner of Bridge and Pepper Streets, was also declared redundant in the early 1970's but was reopened in 1975 as the Chester Heritage Centre. Although its history dates from the twelfth century, the present building was heavily restored, in the Perpendicular style, by James Harrison. The medieval structure had already been considerably altered in the late sixteenth century, as six folios of contemporary churchwardens' accounts bear witness.[10] Although there is no subject-art extant from St. Michael's, the churchwardens' accounts which start in 1560 do record a number of relevant items now lost.

Finally, the parish church of St. Peter, at the corner of Eastgate and Northgate Streets, requires some consideration. Tradition ascribes the founding of the church to Aethelflaed, daughter of King Alfred, in 907. The internal architecture is primarily fourteenth or fifteenth century, although St. Peter's did not escape the attention of the nineteenth-century restorers. The wall painting of the Nativity was rediscovered under whitewash in the last century and was certainly retouched. Some carved corbels survive, as well as a monumental brass of a lawyer with an unusual hat from the fifteenth century.

The richest ecclesiastical foundation in Chester was the

abbey of St. Werburgh. There were other religious orders in the city--the Benedictine nunnery of St. Mary and houses of the three mendicant orders (Dominicans, Franciscans, and Carmelites)--but their buildings have not survived. St. Werburgh's, however, escaped the destruction which levelled many prosperous monasteries after the Dissolution when the abbey church was made the Cathedral of Christ and the Blessed Virgin Mary for the newly formed diocese of Chester in 1541.

The skills of medieval carvers in stone and wood are well represented in the Cathedral church and, to a lesser extent, in the monastic cloisters and refectory. Three beautiful roof bosses in the Lady Chapel depict the Trinity, the Virgin and Child, and the murder of St. Thomas Becket, whose girdle was owned by the nuns of St. Mary's Priory. The choir stalls possess some of the finest medieval woodcarving in England: the misericords, which are clearly related to those of Lincoln in design, are well-known and illustrate a lively variety of subjects, secular, satiric, and religious;[11] the benchends and poppy heads, some of which, like the two Jesse tree stalls, have detailed biblical iconography; and the less frequently remarked-on corbels from which the canopies spring on the backs of the stalls. The charm and delicacy of late fourteenth-century narrative art is evident even in these small corbels, several of which were originally grouped to represent subjects like the Adoration of the Magi, the Annunciation, or the four gospel writers.

Probably the most remarkable survival with dramatic interest is the sandstone carving of the Assumption with the panel of angel musicians on the west front of the Cathedral. The west front was added during the first abbacy of John Birchenshawe (1493-1524), probably before 1509.[12] The lost play of the Assumption was given special performances by the wives of Chester in the late fifteenth century, one during the period when the west front was built, as several mayors' lists record: "1498 . . . prince Arthur elder brother to King Henry the 8 came to Chester, the 4 of August, the Assumption play was played before him at the Abbey gates. . . ."[13]

It is impossible to pay tribute to the Cathedral carvings without also acknowledging the almost total loss of its painted glass windows.[14] This loss is part of the general story of neglect and destruction which began after the Dissolution and affected all the churches in Chester. The reform acts of Edward VI led to alterations in church fabric, vestments, and liturgy. At St. Mary-on-the-Hill, records report that in 1547 the rood

was taken down and the church walls whitewashed to obliterate ornamentation.[15] The reign of Queen Mary brought temporary replacement of the rood in St. Mary's, and elaborate vestments and an Easter sepulcher appear as late as 1564 in the accounts of St. Michael's,[16] but most of these church furnishings were dispersed during the early years of Protestant ascendancy under Elizabeth I. The Holy Trinity churchwardens' accounts note the fate of at least some of Chester's painted glass: "Payd to Ed. Doby the glasior for mendinge of the glass wyndowes and defacinge of the Images in the same accordinge to the Queen's In'iunctions xs."[17] In the Cathedral, where St. Werburgh's shrine had certainly been dismantled, the dean himself was stealing glass to decorate his benefice in Sefton, Lancs.[18]

The worst damage occurred during the civil war when Chester, loyal to the king, was under siege from September 1644 to February 1646. At the end of the siege, parliamentary forces pulled down the High Cross, defaced the Cathedral choir, broke nearly all the painted glass windows, and removed baptismal fonts.[19] The Jacobean effigies in St. Mary-on-the-Hill were saved, perhaps because the family of Sir William Brereton, leader of the parliamentary troops, were benefactors of the church, but the painted glass was broken up: "all the curious windows and figures were, by the Roundheads, caused to be taken down and defaced, and cut in quarrells confusedly, and [the repairs] cost the parish, in the workmanship, £10."[20]

Eighteenth-century neglect was followed by revisionist restoration in the nineteenth century. Alterations to parish churches during this era have already been indicated. The Cathedral underwent three stages of restoration which markedly changed the exterior, removed the Perpendicular features of the Lady Chapel in favor of the Early English style, and replaced the old stone pulpitum and what fragmentary glass remained with Victorian work.[21] The choir stalls were moved twice during this time and some of the carvings which were decayed or thought offensive were exchanged for work "of medieval inspiration" and more acceptable religious content.

Twentieth-century losses have been slighter, although the disappearance of the pulpit from St. Mary's and the effigy in Holy Trinity becomes more significant when we consider Chester's sadly reduced medieval heritage.

Selection and Arrangement

I have included in the list all examples of art with sub-

jects taken from the Bible or saints' legends. Also incorporated under the "Miscellaneous" heading are a number of carvings from the abundant selection in the Cathedral choir which are noteworthy for period costume detail or for their use of popular legend sources. Some items from the undoubtedly large inventory of lost art have been listed, where printed references to manuscript evidence have pointed to their existence. I have not been able to search unprinted records for lost subject-art, but in most cases, notice of an item of possible iconographical interest is barely suggestive and seldom descriptive. Wherever possible, I have provided reproductions of antiquarian sketches or photographs where an item has become badly worn or lost in this century. I have also attempted to add brief citations to other printed works where a lost subject has been illustrated. All manuscript and secondary sources of direct use in the research are given in the Bibliography. As many photographs as possible have been included to complement the verbal descriptions which are only limited substitutes for examination of art *in situ*.

I have added only one manuscript illumination to the subject-list of local Chester art. The Tanner Crucifixion appears in a twelfth-century Psalter known to be of Chester provenance, but I have not found evidence of any flourishing school of manuscript illumination in the area and the manuscripts surviving from the abbey's collection are few.[22]

The subject list is organized according to the categories established in *Drama and Art*, Chapter IV. Old and New Testament subjects are in chronological sequence with apostles, saints, and miscellaneous entries following. Items from different locations under the same heading are also arranged chronologically. Where there is cause to debate an identification, I have indicated the problem as part of the related descriptive paragraph.

Exact dating is the thorniest issue for anyone making a purely visual examination of badly worn or restored works of art. Dates assigned by antiquarians can often be misleading, and without manuscript evidence for an object's manufacture, I have had to rely upon costume details or knowledge of a church's architectural history to provide clues for approximate dating.[23]

NOTES

[1]Lawrence M. Clopper, ed., *Chester*, Records of Early English Drama (Toronto: Univ. of Toronto Press, 1979), pp. 6-7.

[2]See the knight effigy from Holy Trinity, pp. 72-74.

[3]Nikolaus Pevsner and Edward Hubbard, *Cheshire* (Harmondsworth: Penguin, 1971), p. 153, record the effigy as hidden by flooring.

[4]The sketch is in BL MS. Harley 2151, fol. 117v.

[5]See Herbert Druitt, *A Manual of Costume as Illustrated by Monumental Brasses* (London: De La More Press, 1906), p. 187.

[6]St. John's was founded by King Aethelred of Mercia according to George Ormerod, *The History of the County Palatine and City of Chester*, 2nd ed. (London, [1875]-82), I, 192. Peter, bishop of Lichfield (1072-85), moved his see to Chester in 1075, but in 1102, the see was transferred to Coventry by Robert de Limesey (1086-1117).

[7]Douglas Jones, *The Church in Chester 1300-1540* (Manchester: Chetham Society, 1957), p. 81.

[8]Ibid., p. 81.

[9]Ibid., p. 115. Jones notes that the optimism implied by church renewal contrasts with the economic depression stemming from civil disorders and the silting up of the River Dee in the fifteenth century.

[10]J. P. Earwaker, "Notes on the Registers and Churchwardens' Accounts of St. Michael's, Chester," *Journal of the Chester and North Wales Architectural, Archaeological and Historic Society*, n.s. 3 (1890 [for 1888-89 and 1889-90]), 40-41.

[11]M. D. Anderson, in "The Iconography of British Misericords," suggests that the Chester carvings were done by the same group of carvers and carpenters who did the stalls at Lincoln c. 1370 (in G. L. Remnant, *A Catalogue of Misericords in Great Britain* [Oxford: Clarendon Press, 1969], p.xxxi). The Chester stalls can also be dated to the late fourteenth century through internal costume evidence.

[12]R. V. H. Burne, *The Monks of Chester: The History of St.*

Werburgh's Abbey (London: SPCK, 1962), pp. 142-43, argues that the shield on the south side of the Virgin bears the coat of arms of the eldest or second son of the king. Because the label of three points denoting the prince no longer has its original color, it is impossible to determine whether the label was argent or ermine, for eldest or second son. The shield does suggest that the west front was completed before the younger son, Henry VIII, became king in 1509.

[13] The mayors' list quoted is in BL Add. MS. 11335, fol. 23. Burne, p. 143, suggests a connection between the visit of Prince Arthur and the dedication of the west front which may have borne his arms. Another special performance of the Assumption play, for Lord Strange, is noted in the mayors' lists under 1489-90 (see Clopper, *Chester*, p. 20).

[14] The half-figure of a king-saint and an unidentified female saint, listed on pp. 54-55, survive from the cathedral but are now in the Grosvenor Museum.

[15] J. P. Earwaker, "The Ancient Parish Books of the Church of St. Mary-on-the-Hill," *Journal of the Chester and North Wales Architectural, Archaeological, and Historic Society,* n.s. 2 (1888), 141.

[16] Cheshire Record Office: P/65/8/1, fol. 22v.

[17] J. R. Beresford, "The Churchwardens' Accounts of Holy Trinity, Chester, 1532 to 1633," *Journal of the Chester and North Wales Architectural, Archaeological, and Historic Society,* n.s. 38 (1951), 128.

[18] Maurice H. Ridgway, "Coloured Window Glass in Cheshire: Part II, 1400-1550," *Transactions of the Lancashire and Cheshire Antiquarian Society,* 60 (1948), 67: "In the 1570's Chester cathedral was already reported to be in great decay and John Nuttall, the dean known as 'the Golden Ass', whose duties included the preservation of his cathedral, was busy stealing the glass to adorn his own benefice at Sefton in Lancashire."

[19] E. Barber, "The Ancient Glass in the Church of St. Mary-on-the-Hill," *Journal of the Chester and North Wales Architectural, Archaeological, and Historic Society,* n.s. 10 (1904), 59.

[20] Quoted by Barber, p. 59.

[21] Restoration work was done by Harrison, c.1820; R. C.

Hussey in the mid-century; and Sir George Gilbert Scott between 1868 and 1876.

[22]N. R. Ker, *Medieval Libraries of Great Britain: A List of Surviving Books*, 2nd ed. (London: Royal Historical Society, 1964), pp. 49-50, gives a meager list of nineteen manuscripts from Chester, now in the possession of British and German libraries.

[23]I have excluded from the subject list two angel corbels in the north choir stalls (N6, N17) which are identified in Brian Bennett's guide to the choir stalls as medieval work. Both corbels are in excellent condition and bear a marked resemblance to other angels carved by nineteenth-century restorers and placed elsewhere in the choir.

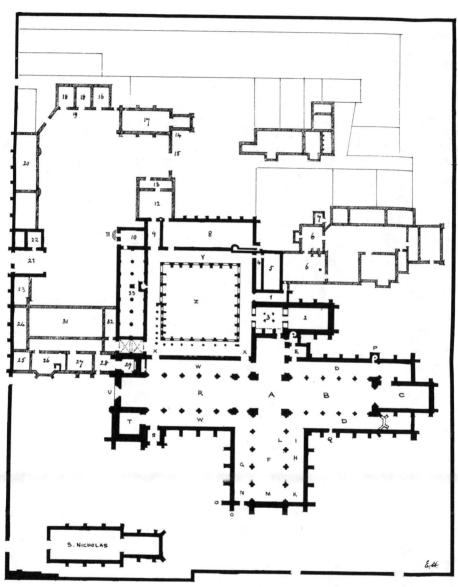

PLAN OF THE MONASTERY OF S.ᵗ WERBURGH CHESTER

KEY TO PLAN OF THE MONASTERY OF ST. WERBURGH

A The body of the church and great central tower
B Choir
C Lady Chapel
D Side aisles of choir
E Vestry
F St. Oswald's Parish Church
G Trough Aisle
H Chancel
I St. Mary Magdalene Chapel
K St. Nicholas Chapel
L Screen
M Steeple door
N South door
O Two buttresses on which steeple stands (bell turret of St. Oswald's Church)
P Stairs over Lady Chapel
Q Door into churchyard
R Broad aisle
S Singing school porch
T Old steeple (Consistory Court)
U West door
W Side aisles to broad aisle
X Cloister doors
Y Cloisters
Z Cloister Garden

1 Maiden's Aisle
2 Chapter House
3 Vestibule
4 Passage and stairs to dormitory
5 Ancient priests' cellar
6 Priests' kitchen
7 Cellars
8 Monks' Hall or Fratry
9 Monks' cellar
10 Passage from Abbey Court through cellar, into cloisters, and so to the Church or Dining Hall
11 Bishop's Gate
12 Kitchen
13 Pantry
14 Passage
15 East Gate of Abbey Court
16 Bakehouse
17 St. Thomas' Chapel (now Dean's House)
18 Brewhouse and Storehouse

19 Great well
20 Great kiln and drying floors
21 Abbey Gates
22 St. Thomas' Court

Abbot's House
23 Porter's lodge
24 Abbot's kitchen
25 Tower and larder
26 Serving man's hall (great dining room above)
27 Strong beer cellar (Darby Chamber above)
28 Pantry (Stone Hall above)
29 Wine cellar
30 Gallery
31 Bishop's Garden
32 Abbot's well
33 Great cellar (Great Hall and Green Hall above)

Plan of the Monastery of St. Werburgh and Key are from the pre-restoration plan of the cathedral included in George Gilbert Scott's article, "On the Architectural History of Chester Cathedral, as developed during the present work of restoration," *Journal of the Chester and North Wales Architectural, Archaeological, and Historic Society*, o.s. 3 (1863-85), between pp. 158 and 159.

LIST OF ABBREVIATIONS

Locations

BL	British Library
BodL	Bodleian Library
BPr	Benedictine Priory of St. Mary
Chr	Chester
ChrCas	Chester Castle
ChrCath	Chester Cathedral
ChrCathC	Chester Cathedral Choir
ChrCathCl-N	Chester Cathedral North Cloister
ChrCathLCh	Chester Cathedral Lady Chapel
ChrCathRef	Chester Cathedral Refectory
ChrCathT-N	Chester Cathedral North Transept
ChrCathT-S	Chester Cathedral South Transept
ChrCathWF	Chester Cathedral West Front
Cs	Cheshire
E	East
FFr	Franciscan Friary
GM	Grosvenor Museum, Chester
HT	Holy Trinity Church
L	Left
Lancs	Lancashire
N	North
R	Right
S	South
StJ	St. John's Church
StJCH	St. John's Chapter House
StJN	St. John's Nave
StMi	St. Michael's Church
StM-H	St. Mary-on-the-Hill Church
StN	St. Nicholas Church
StP	St. Peter's Church
StU	Confraternity of St. Ursula
W	West
WFr	White Friars

The location of painted glass in the windows of St. Mary-on-the-Hill is cited according to the numbering system used in *York Art* and adapted from the *Corpus Vitrearum Medii Aevi*. The only abbreviation used in this context is Tr=tracery, though also I have added in brackets the *Corpus Vitrearum* identification for the tracery lights.

Medium

ESp	Easter Sepulcher
im	image
msi	manuscript illumination
pc	painted cloth
pg	painted glass
pl	plate
rb	roof boss
sc	sculpture
wdcarv	woodcarving
wp	wall painting

N.B.: An asterisk (*) denotes an item destroyed or lost.

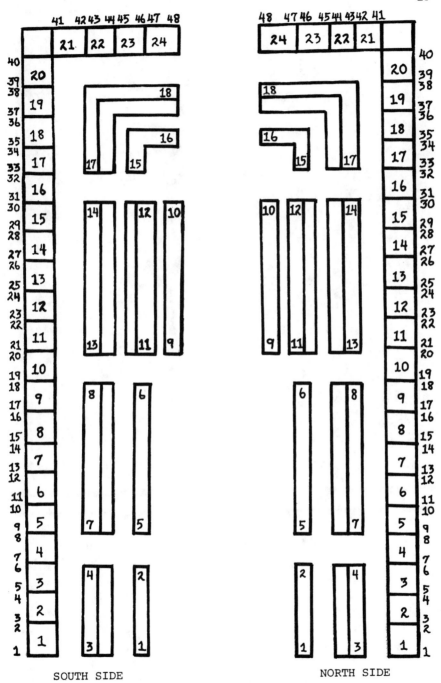

SOUTH SIDE

NORTH SIDE

Diagram of Chester Cathedral Choir Misericords, Benchends, and Corbels.

A SUBJECT LIST OF CHESTER ART

SUBJECT LIST

I. OLD TESTAMENT

ANGELS

StP sc, S aisle wall, stone corbel. 14c? Winged an-
 gel in alb & amice bearing shield with St Geo
 cross. In aisle said to have been St Geo's aisle
 because of chapel there dedicated to St Geo.

ChrCathC wp*, choir wall(?), visible 1909. 14c. 2 winged
 angels in albs holding drapery which hangs in
 folds behind remains of central fig (possibly
 Christ). 2 hands, 1 of which seemed to grasp
 staff & sleeves of robe seen by Barber in 1909.
 Il Barber, "St. Oswald's Reredos," sketch by T.
 Walmsley Price, Pl. facing p. 126.

 wdcarv, N choir stalls, corbel (N5). c.1380.
 Winged angel with long hair wearing alb & play-
 ing lute. Face & L hand obliterated.

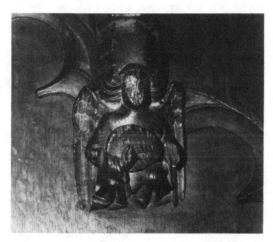

1. Angel Musician with Lute. Chester Cathedral Choir
Stalls, corbel.

 wdcarv, N choir stalls, corbel (N18). c.1380.
 Winged angel with long hair wearing alb & hold-
 ing harp (damaged). L arm broken off, face ob-
 literated.

wdcarv, NW end choir stalls, corbel (NW47).
c.1380. Head & shoulders of winged angel with
curly hair wearing alb. Face & arms semi-oblit-
erated.

wdcarv, NW end choir stalls, corbel (NW48).
c.1380. Curly-haired angel with wings wearing
alb. Head & shoulders only; face & hands oblit-
erated.

wdcarv, N choir stalls, benchend (N12). c.1380.
6-winged seraph in feathers; at top, angel head
& chest, with R hand raised. Good condition.

wdcarv, N choir stalls, benchend top (N16).
c.1380. Winged angel in feathers, head & chest
only. Good condition.

wdcarv, N choir stalls, misericord (N8). c.1380.
Angel with splendid wings, short curly hair &
cross circlet, wearing alb, with bare feet show-
ing, plays citole(?) with plectrum. Heads &
shoulders of 2 feathered angels with same cir-
clets, in stylized clouds on supporters.

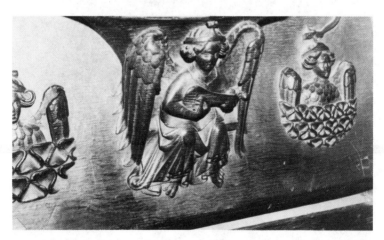

2. Angel Musician. Chester Cathedral, Misericord N8.

wdcarv, N choir stalls, misericord (N22).
c.1380. 6-winged feathered seraph, seated, hold-
ing emblems of Passion (lance & nails). Circlet
with cross on head. Oak-leaves supporters.

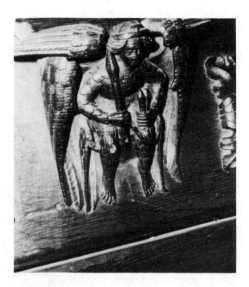

3. Seraph with Emblems of Passion. Chester Cathedral,
Misericord N22.

ChrCathC wdcarv, corner of S & SW return stalls. c.1380.
 6-winged seraph in feathers. Face & arms dam-
 aged. Il Barber, "Stalls, Misereres, and Wood-
 work," Pl. facing p. 48.

 wdcarv, S choir stalls, corbel (S33). c.1380.
 Winged angel with long hair wearing alb kneels
 holding circular object (mirror?). Face oblit-
 erated. See fig. 4, below.

 wdcarv, S choir stalls, arm-rest of seat with
 misericord S14. c.1380. Head & shoulders of
 winged angel in alb with curly hair.

 wdcarv, S choir stalls, benchend top (S16) both
 sides. c.1380. 2 winged angels in feathers,
 head & chest only. Faces in good condition.

 wdcarv, S choir stalls, benchend mouldings (S16),
 both sides. c.1380. 8 seraphs in feathers, with
 cross circlets on heads, holding triangular ob-
 jects with fleur-de-lys; 2 carved angel heads
 with wings at top of mouldings.

wdcarv, S choir stalls, misericord supporters
(S16). c.1380. Feathered angels, long curly
hair, bareheaded with wings; head & shoulders
only on R; to waist on L. Main subject of miser-
icord is a wrestling match (see pp. 69-70).

wdcarv, S choir stalls, misericord supporters
(S24). c.1380. Robed angel with wings plays ci-
tole(?) with plectrum on L and R supporters of
misericord with Coronation of BVM (see p. 48).

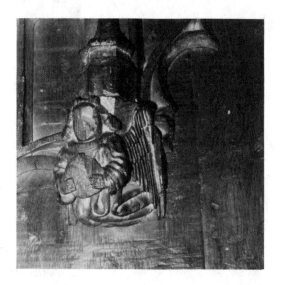

4. Angel Kneeling. Chester Cathedral Choir Stalls,
corbel.

ChrCathT-S pg*, E Window on E side of S transept, tracery
light. Late 14c(?) (date of S transept). Frag-
ment of fig of angel with ruby glass surrounding,
noted by Frater at time of restoration of
ChrCath: "1873, July 8th--Taking the old glass
out of the window south and first window on E
side of E aisle of south transept. Found in two
of the tracery openings of east window the old
stained glass. One piece had part of the figure
of an angel and filled up round with beautiful
ruby glass. The other piece was foliage decora-
tion" (Ridgway, "Coloured Window Glass I," p.
69).

ChrCathRef sc, below Ref roof (2 14c corbels removed at one time but returned when Crossley's new hammer-beam roof was erected, 1939). 14c (9 corbels at E end) and 15c (7 at W end). 14c angel heads with long curly hair, possibly feathered. 15c angels, winged (to waist), with circlets having small cross over brow, short curly hair & wearing albs. 2 on R hold shields.

ChrCathT-N wdcarv(?), not visible, supporting ribs of ornamental oak roof of N transept. Roof erected 1518-24. Angels holding emblems of Passion: "the roof of the north transept, like those of wood, is alone ornamental, the ribs being supported by saints and angels, bearing emblems and shields of arms" (Wild, *Illustration*, p. 6). Described also elsewhere: "The roof of the north transept is finished in wood, the ribs being supported by figures of Angels, bearing the spear, the pincers, and other emblems of the Crucifixion" (Hanshall, *History*, p. 224).

ChrCathCl-N sc, E section of N cloister, stone corbel. Early 16c? (cloister built 1525-38). 2 angels (to waist) with heads intact, short curly hair, wearing crossed stoles over albs, wings visible at side. Hold shield, devices obliterated.

 sc, 3rd from E, stone corbel. Early 16c? 2 angels with heads now lost, wearing albs, 1 wing visible on both edges of corbel. Appear to hold object (shield?).

StM-H im* mentioned in churchwardens' accounts, 1554: "Item payd for setteng vp of the angell vjd" (Cheshire Record Office: P 20/13/1).

SAMSON

ChrCathC wdcarv, N choir stalls, corbel (N21). c.1380. Samson, blind, at Gaza. See also David & lion wdcarvs, sometimes identified as Samson & lion.

KING DAVID

ChrCathC wdcarv, N choir stalls, corbel (N22). c.1380.
David & lion.

wdcarv, S choir stalls, misericord (S4). c.1380.
David pulling open jaws of lion while astride its
back. David is clean shaven & bareheaded, wearing
jupon, girdle, hose, & pointed shoes with ankle
straps. Man watching to L in foliage. 2 gulls
on sea as supporters. Also identified by Howson,
Handbook, p. 64, as legend of Richard the Lion-
hearted with gulls to indicate overseas location
(see Appendix III).

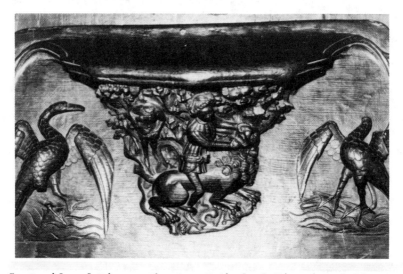

5. David and Lion. Chester Cathedral Misericord S4.

JESSE TREE

ChrCathC wdcarv, dean's stall, benchend (S18). c.1380.
Jesse lies at bottom, head on pillow. Tree
rises up benchend & its mouldings with 22 figs,
some crowned kings holding scepters. Coronation
of BVM at top (see pp. 47f). See fig. 6, below.

wdcarv, archdeacon of Macclesfield's stall,
benchend (N3). c.1380. Jesse lies sleeping on
arm-rest with tree winding up and around bench-
end mouldings. Figs wear crowns & carry swords

or scepters. David carries harp. Il Barber,
"Stalls, Misereres, and Woodwork," Pl. facing p.
52; Crossley, "Stallwork in Chester," between pp.
98-9.

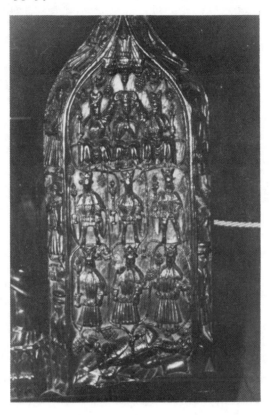

6. Jesse Tree. Chester Cathedral, Dean's Stall, bench-
end.

II. PARENTS OF VIRGIN & HER LIFE (TO NATIVITY)

BVM

ChrCathC
sc*(?), S wall, "at the head of the tomb of Godestald." Im reputedly worked miracles. Brownbill, "A Chester Miracle," p. 47, quotes the following account from Bodl MS 73, f. 49: "When therefore the procession took place, and passed by that image with a great crowd of people, a stand was made near it. But as the Carmelites were passing by it and honoured it, the image raised itself up and with its finger pointing to them said in the hearing of all: 'Lo! my brothers beloved and forechosen,' as if to each it should say that text--'He is made to me a brother especially.' (Ecclus xxix.)."

StN
sc*(?). c.1264. Im mentioned in Moore MSS: Fulk de Orreby granted 1/2 mark toward maintenance of lights before BVM's im. See Bennett, "Black Friars," p. 40.

ChrCath
counter seal of dean & chapter. Mid-16c. BVM with crown & halo stands to L of seated fig of Henry VIII holding book. V appears to lower L of BVM as identification. See fig. 29, below.

StM-H
im* mentioned in churchwardens' accounts, 1554: "Item payd to Ry*chard* leche for gyllydyng of a nemych of owr lade xx d" (Cheshire Record Office: P 20/13/1).

ANNUNCIATION

StJCH
rb, from roof of chapels, excavated 1870. 14c? Winged Gabriel with short curly hair, wearing alb, holds scroll with L hand; BVM on R in simple gown & mantle, arms lost. See fig. 7, below.

ChrCathC
wdcarv, archdeacon of Macclesfield's stall, benchend spandrel (N3). c.1380. BVM kneels at lectern with book. BVM also has halo & hair long & loose, wears gown & mantle with clasp. Urn with 3(?) lilies in center. To R is feathered Gabriel on bended knee with lavish wings. See fig. 8, below.

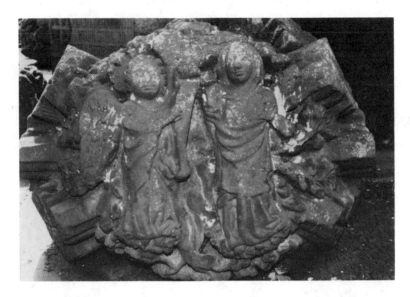

7. Annunciation. Roof boss from St John's Church, now in Chapter House.

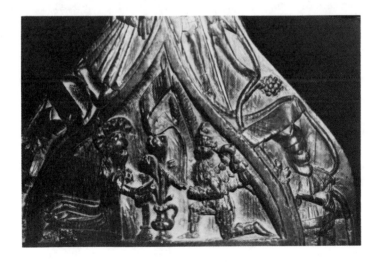

8. Annunciation. Chester Cathedral Choir Stalls, benchend.

ChrCathC wdcarv, N choir stalls, corbels (N23, 24).
 c.1380. Gabriel in feathers, kneeling.

Face, arms, & feet obliterated (N24). BVM kneeling, in mantle & gown. Vase of lilies on pedestal behind. Face obliterated (N23).

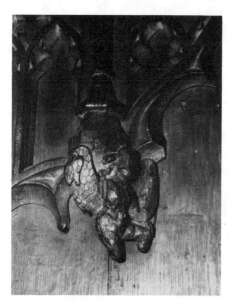

9. Annunciation. Chester Cathedral Choir Stalls, corbels.

III. THE INFANCY OF CHRIST

NATIVITY

ChrCathC wdcarv, SW choir stalls, corbels (SW45, SW46).
c.1380. Jos kneeling, face obliterated (SW46).
BVM seated with Child in swaddling clothes on
her lap. Faces obliterated (SW45).

BVM & CHILD

BPr seal, second half of 12c. Pointed oval about 3"
x 2" showing BVM crowned & seated on throne hold-
ing Child on L knee & scepter in R hand. Lombar-
dic caps legend: SIGILLUM CONVEN . . . MONIALIUM
CESTRIE.

WFr seal, Carmelite Friary, 13c. 1 5/8" x 1 1/8"
pointed oval, showing BVM standing on carved cor-
bel holding Child on L arm. Candle in candle-
stick on each side. Lombardic caps legend:
SIGILLUM PRIORIS CESTRIE *FRATRORUM* DE CARMELO.

ChrCathLCh rb, central position, 2nd bay crossing. c.1260.

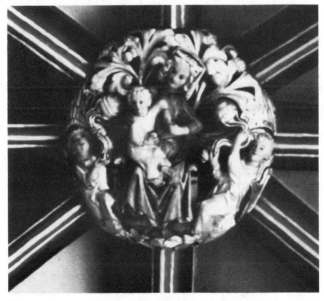

10. Virgin and Child. Chester Cathedral Lady Chapel,
roof boss.

Repainted 1960. BVM (in simple gown, mantle, veil, & fillet head-dress) holds Child in gown on R knee. Child holds orb. Winged angel in alb, on both sides, faces BVM on bended knee & swings large censer. Foliage background.

ChrCath prior's seal, St. Werburgh's Abbey, 13c? Pointed oval 1 7/8" x 1 1/4" showing BVM with Child on L knee seated in niche under trefoiled arch. Angel holding candle in candlestick on R; fig on L broken away. Half fig in prayer facing L in base under trefoiled arch with church towers at sides. Lombardic caps legend: . . . PRIORIS

ChrCathC wdcarv, S choir stalls, misericord (S11). c.1380. BVM, wearing open crown, gown, & pointed shoes, sits with Child on R knee, supported by angel in alb on either side. Child's head & head of angel on L defaced. Pelican feeding young from breast on both supporters.

11. Virgin and Child. Chester Cathedral Misericord S11.

BPr seal, early 16c. Pointed oval 2 1/2" x 1 1/2" showing BVM crowned & seated in canopied niche with tabernacle work at sides, holding Child with crown & nimbus standing on her L knee. BVM holds scepter in R hand. Prioress kneels in prayer in base under round arch. Lombardic caps legend: *SIGILLUM COMMUNE* PRIORISSE & *CONUENTUS MONIALIUM*

SANCTE MARIE CESTRIE.

StP sc* in 2'9" high x 12" wide niche with ogee and cusped head in SE pillar of baptistry. Unknown date. Probably destroyed in 1646 or removed before then. Simpson (*History*, p. 38) thought that Puritan rector Nicholas Byfield (1608-15) would have objected to it.

ANGEL APPEARING TO SHEPHERDS

StP wp, SE pillar of baptistry, painted around now lost im of BVM and Child in niche. 14-15c? Retouched 19c after discovery during restoration work. 2 scenes visible: on R, winged angel in alb with long fair hair & large wings appears to shepherds (no longer clear). Far L, hill of Calvary with one large tree, 2 smaller trees (representing 3 crosses), & 3 birds (representing souls) flying away, 2 to R & one (impenitent thief) to L. Retouched green background. Be-

12. Angel appearing to Shepherds. St. Peter's Church, baptistry pillar, wall painting.

tween 2 scenes, around niche, half-timbered
arched stable roof. Scroll originally over
niche, supported to L by another winged angel in
alb, with words "Gloria in excelsis Deo" and pos-
sibly Adoration of Magi to immediate L of niche
(Richards, p. 122).

ADORATION OF MAGI

ChrCathC wdcarv, N choir stalls, corbels (N25, 26, 37).
c.1380. Crowned kings in girdled jupons, hose, &
mantles, kneeling on L knees. Faces & hands ob-
literated (N25, 26). Originally part of Nativity
group?

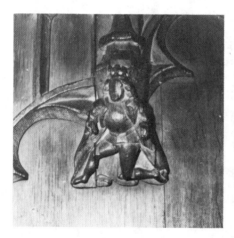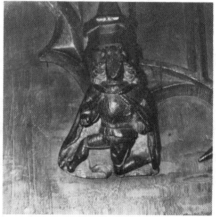

13. Kneeling Kings. Chester Cathedral Choir Stalls,
corbels.

IV. CHRIST'S MINISTRY

JOHN THE BAPTIST

StJN wp, pier at end of N aisle, W of chancel arch.
 Date uncertain; rediscovered and retouched 19c.
 St Jn, with long, straight black beard & hair,
 red nimbus, wears gold & white gown & mantle of
 red & white with border. He holds closed book
 with clasp in L hand, while R hand points to it.
 Small white lamb (with banner?) rests on book.
 On upper R is red building with 3 towers (StJ?),
 trees surrounding on all sides. To st's lower R
 are 3 buildings on small scale (village?) with
 brown outlines. Behind st to L are 3 stags &
 dog. See fig. 14, below.
 Ormerod in early 19c saw more of wp: "The
 mantle of the saint is red and white, with a bor-
 der of gold, over a yellow and white habit. To
 the left, enshrouded in trees, is a building of
 an ecclesiastical character, which it is believed
 represents the original church. Its features are
 apparently Saxon. It has a square tower and two
 others, with gilded banners (once probably bear-
 ing the lamb), flying from the apse-like roofs.
 The other figures are suggestive of the chase,
 there being an elephant and castle, a dog, and
 several stags (some emparked), in a richly wooded
 landscape" (Ormerod, I, 318n). Possibly related
 to picture in description quoted by Ormerod, I,
 192: "King Ethelred, minding to build a church,
 was told, That where he should see a white hind,
 there he should build a church; which hind he saw
 in the place where St. John's Church now standeth;
 and in remembrance whereof, his picture was
 placed in the wall of the said church, which yet
 standeth on the side of the steeple towards the
 west, having a white hind in his hand."

StJCH sc, formerly in niche of façade. Indeterminate
 date. Seated & robed fig with beard. Badly
 worn.

AGNUS DEI

ChrCathCl-N rb, N cloister vaulting. Early 16c? (cloister
 built 1525-38). Lamb with pennant. Il Barber,

"The Cloisters," Pl. facing p. 10.

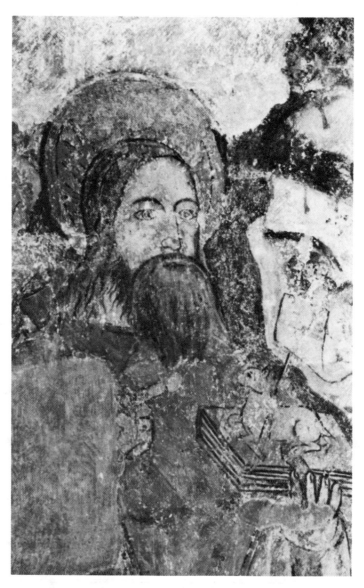

14. St John the Baptist. St John's Church, nave, wall
painting.

TRANSFIGURATION

ChrCathC wp*, N side of NE pillar surrounding tower. Late 15c? (Simon Ripley, abbot 1485-93). Christ in center with Moses and Elias on either side, 3 apostles in front, center one lying on ground, all 3 in poses of adoration. To R "was introduced a figure of this Abbot [Ripley], under a canopy, with a book in one hand and the other lifted up in the act of blessing, and the ring upon the fourth finger" (Ormerod, I, 253). Canopy under which he stood read "Symo: Ripley: Ab-

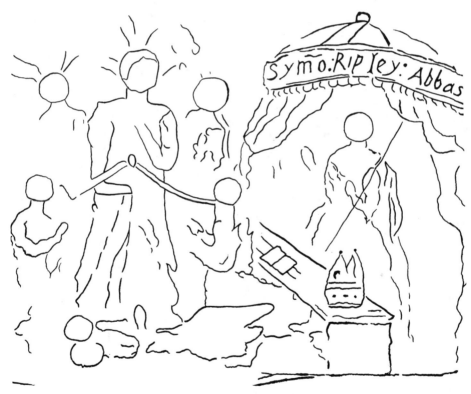

15. Transfiguration. Chester Cathedral, wall painting. Drawing by C. F. Barber, "St. Oswald's Reredos," p. 129, from BL MS Harley 2151, f. 57.

bas." On bench in front were his mitre & book,
faint traces of R hand lifted in act of bless-
ing; L hand holds pastoral staff.

V. THE PASSION

BETRAYAL

StJnCH rb from roof of chapels, excavated 1870. Inde-
terminate date; 14c? Badly worn crowd of figs
barely discernible, 2 facing each other in cen-
ter.

16. Betrayal. Roof boss from St John's Church, now in
Chapter House.

SCOURGING

StJCH rb, from roof of chapels, excavated 1870. 14c?
Christ in loin cloth stands center, with hands
tied to column. 2 guards, L & R, in jupons &
girdles & tall conical head-dresses, actively
scourge him. Badly worn. See fig. 17.

SIGNS OF PASSION (& FIVE WOUNDS)

StM-H pg, Troutbeck Chapel, Win S2Tr [A4-6, B2] (since
19c restoration), not *in situ*. c.1500. 4 Pas-
sion shields within roundels: 2 of wounded heart
with wounded hands & feet above & below against
gold background; hammer & 3 ointment jars(?);
cock on perch with gold seamless garment hung

over it. See figs 18-20. See also ANGELS, pp. 19-23, above, and RESURRECTION, p. 44, below.

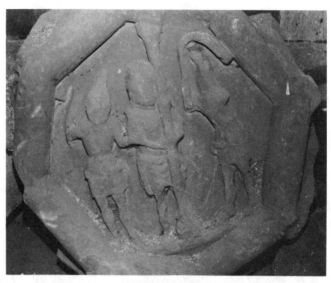

17. Scourging. Roof boss from St John's Church, now in Chapter House.

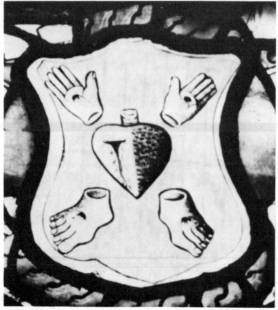

18. Shield with Five Wounds. St Mary-on-the-Hill Church, Troutbeck Chapel, painted glass, Window S2 (tracery).

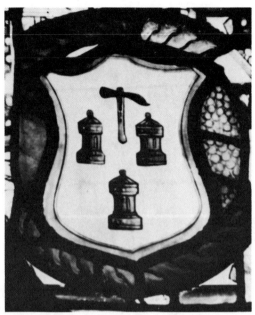

19. Passion Shield: Hammer and Ointment Jars. St. Mary-on-the-Hill Church, Troutbeck Chapel, painted glass, Window S2 (tracery).

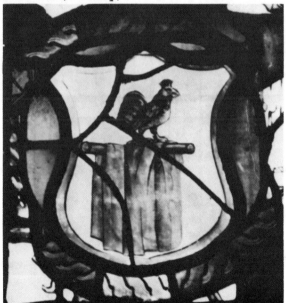

20. Passion Shield: Cock. St Mary-on-the-Hill Church, Troutbeck Chapel, painted glass, Window S2 (tracery).

JESUS

ChrCathC wdcarv, N choir stalls, corbel (N38). c.1380.
 Christ, seated, wearing crown of thorns, simple
 robe with mantle(?) draped over knees. Face &
 arms gone.

CRUCIFIXION

BodL msi, Psalter & Masses, Bodleian MS Tanner 169, f.
 149r (Chester provenance). c.1192-3. Christ on
 cross, center, with Mary (L) & Jn (R). Personi-
 fications of Sun (L) & Moon (R) drawn in brown
 ink. Cross decorated with red ink, also blood

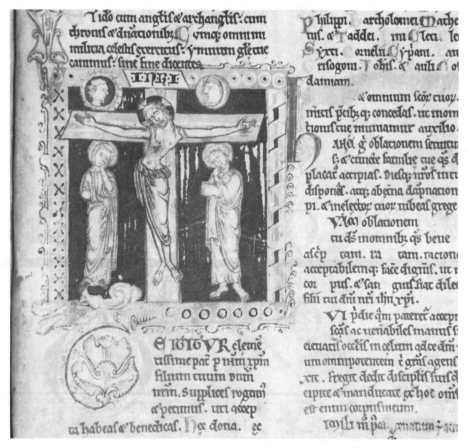

21. Crucifixion. Bodleian MS Tanner 169, f. 149r.

from wounds. Background deep blue, with border
of geometric motifs in red & blue ink.

StM-H wp, S wall, entrance to Troutbeck Chapel. c.1460-
1500; restored 19c. Christ with nimbus & loin
cloth on cross, head hanging down, arms strained
back. BVM with rays radiating from covered head
on R of Christ, St Jn originally on L (almost ob-
literated). Against background of foliage. Dis-
covered under plaster & whitewash during restora-
tion in 1848. To L of Jn was archbishop (now

22. Crucifixion with Other Subjects, including unidentified
crowned figure, above. St Mary-on-the-Hill Church, wall paint-
ing at entrance to Troutbeck Chapel. Line drawing from "The
Late Rev. W. H. Massie," Pl. facing p. 400.

gone) in full Eucharistic vestments: mitre, alb, tunicle, & chasuble, with archiepiscopal purple crossed pall & cross-staff held in L hand. Above Christ is robed fig, badly worn, wearing open crown with cross. Holds book(?) in L hand & scepter(?). Variously identified as Henry VI (on throne when Troutbeck Chapel was erected) or representation of Christ as King, although no nimbus.

ROOD

StJ im* connected with shrine erected to hold piece of true Cross. Referred to in will of Alderman Ralph Davenport, 1505, when he bequeathed "five large candles of wax to the college church of St. John, before the image of the Crucifixion." Cited by Jones, *Church in Chester*, p. 51n. Relic of true Cross was important local shrine, known throughout Cs, Lancs, & N Wales as "Crucifix of Chester."

StN wdcarv*(?) noted in inventory of goods in vestry made at Dissolution: "A peynted clothe to hang before the Roode" (Bennett, "Black Friars," p. 41).

WFr wdcarv*(?), noted in inventory of goods in vestry made at Dissolution: "A cloth for the Roode" (Bennett, "White Friars," p. 45).

StM-H sc* mentioned in churchwardens' accounts as taken down, 1547: "Item payd for takyng downe of the Rode ij d." A second rood cited in churchwardens' accounts for 1554: "ffor makyinge the Rode xij s. . . . Item for gyldenge the Rode to Ry*chard* leche xiij s" (Cheshire Record Office: P 20/13/1).

HT wdcarv* mentioned in 16c churchwardens' accounts for 1558-9 (26 March): "payd to Rafesonne Greff makinge the Roode & mendinge the Mary & Iohn xij s"; "payd to Rich leche for payntinge the Rode & the Mary & Iohn 14 s" (BL MS Harley 2177, f. 27r).

EASTER SEPULCHRE

HT ESp* mentioned in 16c churchwardens' accounts for 1535: "rec of mr. bomvell of the gift of his wife a fyne napkyn of Calico cloth trelyd with silk to Cover the Crosse in ye sepulcre" (BL MS Harley 2177, f. 20v). Also referred to in 1545-6 (f. 21v), 1553 (f. 23r), 1555 (f. 23v), 1557 (ff. 25r-25v), etc.

StJ ESp* noted in 1518 will of Nicholas Deykyn of Chester, who left his best bed covering "to be hanged about the Easter sepulchre there" (Burne, "The Falling Towers," p. 12).

StMi ESp* included in church inventory of goods handed to churchwardens elected 23 April 1564 (Cheshire Record Office: P 65/8/1, f. 22v): "Ittem a frame that was the Sepulchre."

StM-H ESp* mentioned in 16c churchwardens' accounts for 1536 (16 April): "Item payd for naylys pynes and [the thred] Thred to Heng the sepulcur ij d." (Cheshire Record Office: P/20/13/1, f. 2v).

WFr ESp* noted in inventory of goods in vestry made at Dissolution: "A cloth for ye sepulchre" (Bennett, "White Friars," p. 45).

VI. THE RISEN CHRIST

RESURRECTION

StM-H wp*, S wall, window jamb adjoining entrance to Troutbeck Chapel. Ascribed to late 15c. Discovered under plaster & whitewash; restored mid-19c. Half-fig of Christ with nimbus & loin cloth rising from box-tomb. Symbols of Passion above: ladder, sponge filled with vinegar on a reed, tau cross & spear. Now obliterated. See fig. 22, above.

APPEARANCE TO BVM

ChrCath seal of dean & chapter. Mid-16c. BVM kneels in gown & mantle on L at prayer desk with open book, facing Christ on R. Christ has cruciform nimbus & wears long mantle with clasp, edges held up to knees, apparently by L elbow; arms, legs, & feet bare. Christ holds cross-staff in R hand, with

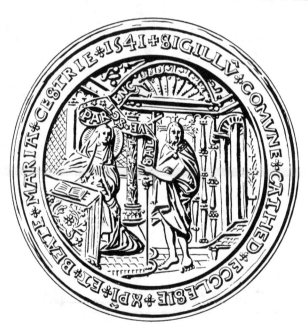

23. Appearance to BVM. Seal of Dean and Chapter, Chester Cathedral, from Burne, "The Founding of Chester Cathedral," Pl. facing p. 42.

scroll flowing from L hand bearing letters "SALVE
SCT PAR ENC." Elaborate renaissance architectur-
al background, tiled floor. Inscription around
edge: SIGILLV̄ COMVNE CATHED ECCLESIE XPĪ ET
BEATE MARIA CESTRIE 1541." Counter seal of Hen-
ry VIII with St Oswald & BVM (see fig. 29, below).
Il Ormerod, I, 265, from seal attached to deed
dated 33 Henry VIII.

ChrCath bishop's seal, first bishop of Chester, Jn Bird,
1549. Pointed oval, 70mm x 47mm, showing Christ
on L with halo, R hand raised & L hand holding
orb; BVM on R with halo & rays of glory, hands
held in prayer. Both figs facing front wearing
long robes, with bird (dove?) hovering over head
of each. Figs framed by carved double-arched
niche; ornamental shield of arms in base. Lom-
bardic caps legend: SIGILLV[M . . .] DEI GRA
CESTREN*SIS* EPISCOPI.

VII. CONCLUSION OF LIFE OF THE VIRGIN

ASSUMPTION

ChrCathWF sc, red sandstone, above W door. Late 15c or

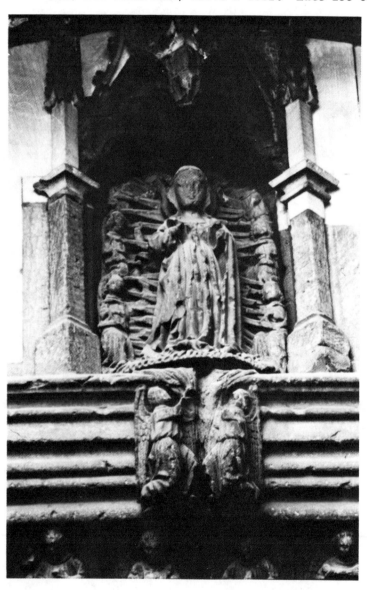

24. Assumption. Chester Cathedral West Front.

early 16c. BVM stands under canopy in mandorla
wearing simple round-necked gown with loose
sleeves & mantle. Covrechef on head, L hand
held over heart. R arm broken off. Features on
face still visible. 3 angels in albs (no wings
to be seen) on either side of BVM facing her.
Immediately below, on door lintel, 2 angels in
albs with feathered wings & uplifted heads, swing
censers on bended knee. On panel below (above
square-headed doorway), are 8 angels with curly
hair & feathered wings; feathered angels alter-
nate from L with angels in albs. From R, angel
holds broken string instrument (lute?); angel
with harp; angel holding instrument with both
hands (transverse flute?); angel playing shawm;
angel with arms broken off; angel with serpent(?)
or scroll; angel with arms gone; angel holding
shield. To L & R, edges, angel playing positive
organ with another angel working bellows; 6 an-
gels in albs on either side sing in procession
toward center. Some variation in pose.

CORONATION OF BVM

ChrCathC wdcarv, dean's stall, benchend top (S18). c.1380.
 BVM sits with hands in prayer, loose, flowing
 hair, long-sleeved gown & mantle. Son & Father
 on either side hold open crown on her head. Son
 & Father wear identical crowns & are dressed as

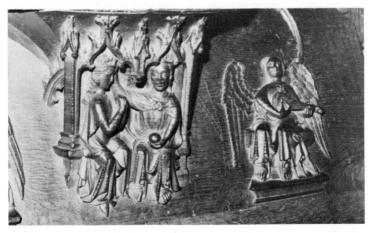

25. Coronation of Virgin. Chester Cathedral Misericord S24.

kings, holding scepters. Above BVM, dove flies
downward. See fig. 6, above.

ChrCathC wdcarv, S choir stalls, misericord (S24). c.1380.
Crowned, clean-shaven Christ in long robe & mantle
with ornamental clasp sits holding orb in L hand
& crowning BVM seated on his R with hands held in
prayer (junctus manibus) under decorated canopy.
BVM wears gown & mantle. Robed angel with wings
plays citole(?) with plectrum on L & R support-
ers. See fig. 25, above.

VIII. CHRIST IN MAJESTY & TRINITY

CHRIST IN MAJESTY

StJCH
rb, from roof of chapels, excavated 1870. 14c?
Christ seated in glory with R hand raised. Badly
worn. Il Scott, *Guide*, sketch p. 240.

StM-H
wdcarv, pulpit panel, originally in StM-H, dis-
persed upon church becoming redundant 1972.
Present location unknown. Late 15c or early 16c.
Mentioned in churchwardens' accounts from 1543
(Richards, p. 113). Bearded Christ in glory,
wearing loose gown with tight sleeves of under-
garment visible below elbow. Seated between 2
winged angels in albs blowing shawms. Holds orb
with L hand, R arm raised in blessing (hand
gone). Robe appears to be fur-trimmed. Other
panels represented angel, ox, & eagle of St
Matt, St Luke, & St Jn. See fig. 26, below.

FFr
seal, pointed oval about 1 1/2" x 1", surviving
impression on document dated 1528, Chester City
Record Office, illustrative material, no. 32.
Christ crowned & wearing long robe reigns from
Cross. Surrounding legend in Lombardic caps:
SIGILLUM FRATRVM MINORVM CESTRIE. Il Little,
Franciscan History, Ch. V, Pl. III; "the Cruci-
fixion on the Chester seal . . . can rank amongst
the best examples of the seal engraver's art, an
art in which English craftsmen had few if any
equals" (ibid., p. 83).

TRINITY (WITH CHRIST ON CROSS)

ChrCathLCh
rb, E bay, regilded 1960. c.1260. Trinity:
Father in open floriated crown, alb, bare feet,
seated holding crucifix with Son in loin cloth on
it; dove rests on arm of Cross whispering, as
comforter, into Christ's ear. Winged angel with
short hair in alb swings censer on either side.
See fig. 27, below.

HT
sc*(?) referred to in 16c churchwardens' accounts
for 1558: "payd for the diademe & Armes & other
thinges laking to the Image of the Trinity ij s
vj d to Rich leche for payntinge the Trinity 6 s

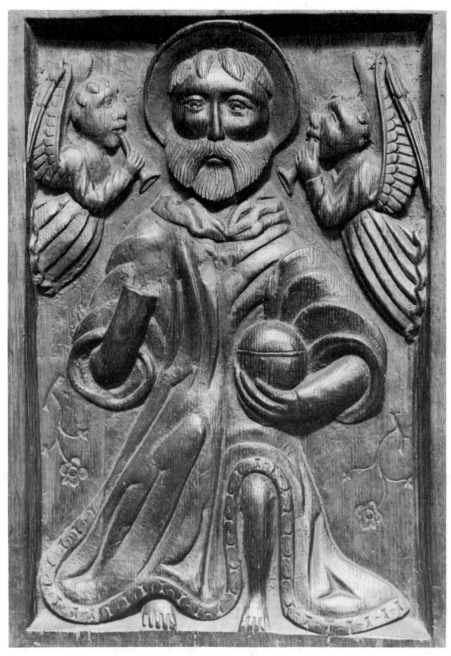

26. Christ in Majesty. Pulpit panel, formerly in St Mary-on-the-Hill Church and now location unknown.

8 d" (BL MS Harley 2177, f. 26v).

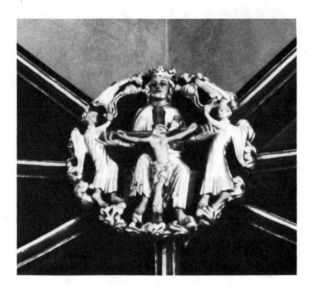

27. Trinity. Chester Cathedral Lady Chapel, roof boss.

IX. THE APOSTLES

APOSTLES AS A GROUP

StMi pc* of 12 apostles, "the clothe of the xij of a
 postles" (Cheshire Record Office: P/65/8/1, f.
 27r). Sold with another cloth for 3d in 1564.

APOSTLES (INDIVIDUAL FIGURES)

St John the Evangelist

 See listing under FOUR EVANGELISTS, *below.*

St Mark

 See listing under FOUR EVANGELISTS, *p. 53, below.*

St Matthew

 See listing under FOUR EVANGELISTS, *p. 53, below.*

St Paul

ChrCath seal, St Werburgh's Abbey, in use in 1271 & 1538.
 Reverse includes fig of St Paul in R transept
 holding sword in R hand & book in L. See des-
 cription of seal under ST WERBURGH, p. 63, below.

St Peter

ChrCath seal, St Werburgh's Abbey, in use in 1271 & 1538.
 Reverse includes fig of St Peter standing in L
 transept. See description of seal under ST WER-
 BURGH, p. 63, below.

StN sc*(?) in choir. Im mentioned in Dissolution in-
 ventory: "A peyre of yron boltes before seynt
 Peter" (Bennett, "Black Friars," p. 40).

FOUR EVANGELISTS

St John the Evangelist

ChrCathC wdcarv, N choir stalls, corbel (N31). c.1380.
 St Jn kneeling with writing tablet in L hand,
 obliterated eagle on R. Face gone.

StM-H wdcarv*, pulpit panel, originally in St Mary-on-
 the-Hill Church, present location unknown. Late
 15c or early 16c. Eagle of St Jn. See also
 CHRIST IN MAJESTY, p. 49, above.

St Luke

ChrCathC wdcarv, N choir stalls, corbel (N32). c.1380.
 St Luke with head resting on L hand, R hand hold-
 ing book. Head of ox looks over his shoulder.

StM-H wdcarv*, pulpit panel, originally in St Mary-on-
 the-Hill Church, present location unknown. Late
 15c or early 16c. Ox of St Luke. See also
 CHRIST IN MAJESTY, p. 49, above.

St Mark

ChrCathC wdcarv, N choir stalls, corbel (N28). c.1380.
 St Mark kneeling at work on scroll, with lion
 looking over R shoulder. Face obliterated.

St Matthew

ChrCathC wdcarv, N choir stalls, corbel (N27). c.1380.
 St Matthew kneeling & holding open book with
 angel behind R shoulder. Both faces obliterated.

StM-H wdcarv*, pulpit panel, originally in St Mary-on-
 the-Hill Church, present location unknown. Late
 15c or early 16c. Angel of St Matthew. See also
 CHRIST IN MAJESTY, p. 49, above.

X. SAINTS

Each st in the list below is briefly identified in order to prevent confusion. Reference is also made for convenience to the Herder *Lexicon der Christlichen Ikonographie. Dates for feast days in the Chester calendar are supplied from the Bodleian Tanner MS 169, pp. 3-14, published in* English Benedictine Kalendars After A.D. 1100, *ed. Francis Wormald, Vol. I: Abbotsbury-Durham (London, 1939), pp. 95-111.*

SAINTS (AS A GROUP)

ChrCath sc, St Werburgh's shrine, moved to S side of choir from ChrCathLCh soon after Reformation (until 1876) & converted into bishop's throne. Now at entrance of ChrCathLCh. Early 14c, partly & imperfectly restored 1748. 34 figs of kings & sts of Mercia, holding scrolls on which were inscribed their names in Latin (now obliterated). See Appendix I, pp. 81-5. Il, engraving (of bishop's throne), Hanshall, Pl. facing p. 221; photo Addleshaw, p. 17.

StP sc*, ancient high cross dating at least to 1488, standing before St Peter's Church door in Watergate Street. Upper part had 12 panels with sts, now obliterated: 6 on upper & lower levels. Cross thrown down & figs cut out in February 1646 by parliamentary troops. Upper section formerly in Grosvenor Museum but now reunited with shaft. Il Simpson, *History*, drawing facing p. 13.

MALE SAINT (UNSPECIFIED)

GM pg, panel from subject-window formerly in ChrCath. 15c. Three-quarter length fig of haloed king-saint, facing R. Medium-length curly hair & long curly beard. Wears foliated open crown with large halo, aumuce with cross-hatching over loose tunicle. Holds scepter in L hand & wand of peace with scroll winding round in R hand. Brown enamel lines with details of crown, halo, scepter, & tunicle in yellow stain. "The identity of the figure is not clear, but the quality and size of the work indicates that it probably belonged to a panel in a subject-window . . . and is not from a small tracery light where such finer points would

not be employed. If this is so, it would appear that this is the only fragment of such a window left in Cheshire" (Ridgway, "Coloured Window Glass, II," p. 72). Il drawing by Ridgway, ibid., Pl. IX.

FEMALE SAINTS (UNSPECIFIED)

GM
pg formerly in ChrCath, now in GM. Early 15c. Female st with halo & long hair falling in waves to shoulders, facing R. R hand raised. Cloak without morse worn over yellow undergarment.

StM-H
pg, Troubeck Chapel, Win S3Tr [A3], not in situ. c.1475-1500. Previously identified as female st, but more likely composite with head of donor or lay fig (no halo); see Ridgway, "Coloured Window Glass, II," p. 76. Facing R against blue background with some gold stars. Drapery supplied from various sources. Il Barber, "Ancient Glass," Pl. facing p. 63. N.B.: "It would appear from neighbouring and associated fragments that the saints [in the Troutbeck Chapel] have stood upon tiled bases, and that the canopies above them have been supported upon turned columns, whilst small fragments of inscription are not large enough to reveal their identity or a more exact dating. . ." (Ridgway, "Coloured Window Glass, II," p. 77).

StM-H
pg, Troutbeck Chapel, Win S3Tr [A4], not in situ. c.1475-1500. Crowned female st facing L & holding rose. St has halo, long yellow hair, & wears gold gown & white mantle, against red background. Cf Barber, "Ancient Glass," p. 64, who suggests BVM as girl. Originally situated elsewhere (St Catherine's Chapel?).

StM-H
pg, Troutbeck Chapel, Win S3Tr [A5], not in situ. c.1475-1500. Female st facing L and carrying palm branch (traditional symbol of martyrdom) & book. St has halo & long yellow hair & wears gold dress against red background. Originally elsewhere (St Catherine's Chapel?). Il Barber, "Ancient Glass," Pl. facing p. 63.

StM-H
pg, Troutbeck Chapel, Win S5Tr [A6], not in situ.

c.1475-1500. Female st facing L & carrying book
in L hand & sheaf of golden wheat in R. St has
halo & long yellow hair & wears gold gown & white
mantle against red background. Originally else-
where (St Catherine's Chapel?). Il Barber, "An-
cient Glass," Pl. facing p. 65.

SAINTS (INDIVIDUAL)

St Anthony of Egypt

*One of the desert fathers (d. 356). Lexicon V.205-17.
(Jan 17)*

HT sc*(?) referred to in Holy Trinity churchwardens'
 accounts for 1557: "a Image of St Anthony" (BL
 MS Harley 2177, f. 25v).

St Catherine of Alexandria

*Virgin-martyr tortured on the wheel and finally beheaded
by tyrant Maxentius. Lexicon VII.289-97. (Nov 25)*

StM-H pg, Troutbeck Chapel, Win S5Tr [A3], not *in
 situ*. c.1475-1500. Female st facing R, holding
 golden palm branch in R hand & gold-hilted sword
 point down in L hand. St has halo & long yellow
 hair; she wears gold gown & white mantle against
 blue background. Originally this fig was located
 elsewhere; probably this and other female sts
 were part of window in St Cath's Chapel. Fig
 is probably St Cath of Alexandria. See fig. 28,
 below.

St Cyneburgh

*Daughter of Penda, king of Mercia, and wife of Alcfrith of
Northumbria. Paternal aunt of St Werburgh. Founder and
abbess of convent of Castor (Northants).*

ChrCath sc, St Werburgh's shrine, entrance of ChrCathLCh.
 Early 14c; imperfectly restored 1748. See above
 under SAINTS, p. 54, & Appendix I.

St Ermengild

Daughter of Erconbert, king of Kent, and St Sexburgh, and

*wife of Wulfhere, king of Mercia. Mother of St Werburgh
and later abbess of Ely. (Feb 13)*

ChrCath sc, St Werburgh's shrine, entrance of ChrCathLCh.
 Early 14c; imperfectly restored 1748. See above
 under SAINTS, p. 54, and Appendix I.

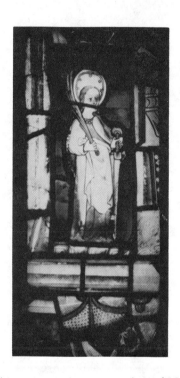

28. St. Catherine. St. Mary-on-the-Hill Church, Trout-
beck Chapel, painted glass, Window S5 (tracery).

St Etheldreda (Aethelthryth)

*Founder and abbess of double monastery at Ely. Daughter
of Anna, king of East Anglia, and aunt of St Werburgh.
Lexicon VI.170-1. (June 23)*

ChrCath sc, St Werburgh's shrine, entrance of ChrCathLCh.
 Early 14c; imperfectly restored 1748. See above
 under SAINTS, p. 54, and Appendix I.

St George

Patron st of England from time of Edw III. Golden Legend gives story of his encounter with dragon in defense of princess. A St Geo's play was performed in Chr in 1429 and St Geo was a key figure in the shows of 1610 and 1621. Lexicon VI.365-90. (April 23)

ChrCathC wdcarv, S choir stalls, corbel (S30). c.1380. St Geo & dragon.

StP sc*, im originally in St Geo's Chapel (of the fraternity of St Geo) in S aisle. Cited by Simpson, *History*, p. 39, from unspecified Harleian MS.

St Kenelm (Cynhelm)

King of Mercia (796-821), but according to legend put to death at instigation of his jealous sister Quendreda after reigning a few months, at age of seven. (July 17)

ChrCath sc, St Werburgh's shrine, entrance of ChrCathLCh. Early 14c; imperfectly restored 1748. See above under SAINTS, p. 54, and Appendix I.

St Lawrence

Deacon at Rome; according to tradition, martyred by being roasted on a gridiron. Lexicon VII.374-80. (Aug 10)

StM-H pg, Troutbeck Chapel, Win S3Tr [A2], not *in situ*. c.1475-1500. Deacon carrying book in R hand & facing R. St wears dalmatic & has tonsure & halo against red background. L hand gone. Originally elsewhere (St Stephen's Chapel?). Probably St Lawrence. Il Barber, "Ancient Glass," Pl. facing p. 63.

St Mildburgh

Second abbess of nunnery at Wenlock (Shrops), founded by her father Merewald, king of Mercia. Lexicon VIII.17. (Feb 23)

ChrCath sc, St Werburgh's shrine, entrance of ChrCathLCh. Early 14c; imperfectly restored 1748. See above

under SAINTS, p. 54, and Appendix I.

St Mildred (Mildthryth)

> *Daughter of Merewald, king of Mercia, and Ermenburgh of Kent. Abbess at Minster-in-Thanet (Kent). Lexicon VIII.17-8.*

ChrCath sc, St Werburgh's shrine, entrance of ChrCathLCh. Early 14c; imperfectly restored 1748. See above under SAINTS, p. 54, and Appendix I.

St Oswald

> *Northumbrian king and martyr, patron of St Aidan. Lexicon VIII.102-3. (Aug 5)*

ChrCath counter seal of dean & chapter. Mid-16c. St Oswald with halo, wearing robe & tippet, stands to L of seated fig of Henry VIII holding orb in R hand & scepter in L. O appears to lower L of st as identification. BVM appears to R of king. See fig. 29, below.

St Stephen

> *Proto-martyr and, traditionally, first deacon. Death by stoning. Lexicon VIII.395-403. (Dec 26; finding of relics, Aug 3)*

StM-H pg, Troutbeck Chapel, Win S5Tr [A5], not *in situ*. c.1475-1500. Deacon facing L with book in L hand & carrying 3 stones in damaged R. Deacon has tonsure & halo & wears dalmatic against blue background. Originally this fig was situated elsewhere (St Stephen's Chapel?).

St Thomas Becket

> *Archbishop of Canterbury, martyred in his cathedral, 1170, by 4 knights who supported Henry II. Lexicon VIII.484-9. (Dec 29; translation, July 7). Nuns of St Mary's Priory had girdle worn by St Tho at time of martyrdom; Bishop William de Cornhill joined in 1220 commission for translation of st's body to E end of Canterbury Cathedral choir and brought girdle back with him to Chr (Ormerod, I, 257n).*

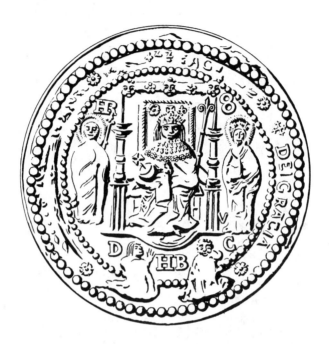

29. St Oswald, Henry VIII, and BVM. Chester Cathedral, counter seal of Dean and Chapter, from Burne, "The Founding of Chester Cathedral," Pl. facing p. 43.

ChrCathLCh rb, W bay. c.1260, regilded 1960. St Tho in alb & cap stands L behind altar with chalice on it, while 4 knights in chain mail & sleeveless surcoats attack with drawn swords. Blomfield claimed that shields of assassins bore their arms: "Fitzurse, whose identity is marked by the bears on his shield, holds his sword with both hands, prepared to strike; but it seems to be Richard de Brez, who bears a boar's head on his shield, who strikes the blow, and the blow is represented as falling on the crown of Becket's head, so as to cut off the scalp" (p. 137). The monk Grim stands to R of St Tho holding crozier. See fig 30, below.

ChrCas pg*(?), smaller chapel near Great Hall. 1301. Compotus camerarie Cestrie cites payment of William of Northampton to paint St Tho with 4 knights: "Willelmo de Norhampton pictori de-

pingenti ymaginem beati Thome Martiris cum
quatuor militibus qui interfecerunt eundem Mar-
tirem in minori capella Castri Cestrie prope mag-
nam aulam per ordinacionem et preceptum domini
Edwardi filii Regis Principis Wallie et Comitis
Cestrie et percipienti de certo pro eadem pic-
tura et pro omnibus coloribus emendis pro eadem
et pro fenestris eiusdem Capelle dealbandis j
marca per convencionem inde secum factam pro
certo illo per manus proprias mense Aprilis anno
presenti xxix° xiij s. iiij d." Quoted by
Stewart-Brown, *Pipe Rolls*, p. 209.

30. Martyrdom of St Thomas Becket. Chester Cathedral
Lady Chapel, roof boss.

St Ursula

*According to legend, a British princess murdered with
11,000 virgins at Cologne by Huns. Lexicon VIII.52-7.
(Oct 21)*

StU seal, Confraternity of St Ursula of Chester.
 16c. St Ursula, with halo & crown, holds palm
 in R hand & arrow in L. On either side figs of
 attendant virgins. Inscription: SIGILLVM
 CON [damaged] VR2VLE DE CESTER. Il Bennett,
 "Hospital and Chantry," p. 109, from sketch of

seal attached to Pentice Chartulary, f. 111.

St Vincent

> *Proto-martyr of Spain; martyred by governor Dacian during Diocletian's persecution. Lexicon VIII.561-6. (Jan 22)*

StM-H pg, Troutbeck Chapel, Win S5Tr [A2], not *in situ*. c.1475-1500. Deacon facing R & carrying large naked sword point down in L hand & book in R hand. St has tonsure & halo & wears dalmatic against blue background. Originally situated elsewhere (St Stephen's Chapel?).

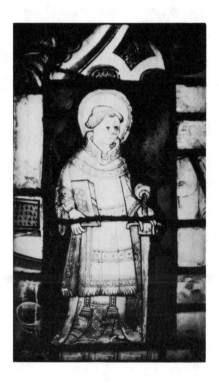

31. St Vincent. St Mary-on-the-Hill Church, Troutbeck Chapel, painted glass, Window S5 (tracery).

St Werburgh

> *Abbess and patron st of Chester Abbey; see Appendix I for details of life. Relics kept in abbey shrine (see p. 54).*

Lexicon *VIII.599.* *(Feb 3; translation to Chr, June 21)*

ChrCath seal, St Werburgh's Abbey, late 12c or early 13c.
 Pointed oval, 3 1/4" x 2 1/8", showing St Wer-
 burgh with halo in grave clothes. Lombardic
 caps legend: SIGILLV[M SANCTE WER]EBVRGE VIR-
 GINI[S]. Il Barraclough, between pp. 8-9, from
 seal on charter of Abbot Robt II of Chester.

ChrCath seal, St Werburgh's Abbey, in use in 1271 & 1538.
 3 1/2" diameter, circular, showing elaborate
 Gothic church, partly elevation, partly section,
 with transepts & round-headed pinnacled tower.
 Under tower arch, St Werburgh seated on throne
 holding pastoral staff in R hand, book in L. In
 transepts L & R, standing fig of a monk facing
 toward center in prayer. Monk's head in quatre-
 foiled panel above in tower & in quatrefoiled
 panel on carved plinth at base. Lombardic caps
 legend: SIGILL[UM CONUENTUS: ECCL]ESIE[:
 SA]NCTE[: WERBURGE] VIRGINIS DE CESTRIE. Re-
 verse shows similar building with fig of king in
 crown on throne below round-headed tower arch;
 he holds scepter fleury in R hand & orb sur-
 mounted with cross in L. St Paul stands in
 transept on R holding sword in R hand & book in
 L; St Peter in L transept. Monk's head in
 quatrefoiled panel on carved plinth at base.
 Lombardic caps legend: PARTITUR PROPRIUM CUM
 MARTIRE VIRGO SIGILLUM.

 rb, abbey gateway, E end, possibly brought from
 elsewhere (different stone & larger size). 14c?
 Demi-fig of abbess in habit with barbe & veil
 head-dress, holding crozier in L hand. See fig
 32, below.

ChrCathC wdcarv, N choir stalls, misericord (N19). c.1380.
 St Werburgh in habit with barbe & veil head-dress,
 holding crozier in L hand, stands to L restoring
 goose to life, servant (or thief?) in tunic on R.
 Geese fly overhead. L supporter: bearded man in
 tunic with bag sleeves, hose, pointed shoes, &
 hood with liripipe, horn hanging by strap at R
 side, stands at L helping St Werburgh in habit
 on R to enclose 6 geese within barrier. R sup-
 porter: abbess with crozier in L hand raises R

hand to suppliant in tunic kneeling on R, geese
flying overhead. See figs. 33-35, below.

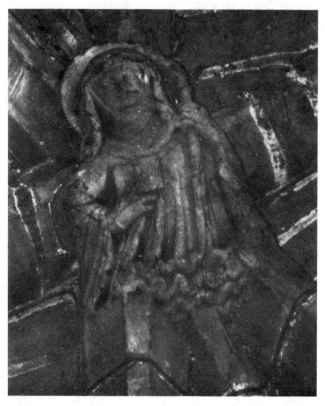

32. St Werburgh. Chester Cathedral, abbey gateway, roof
boss.

ChrCath wp*, mentioned by Williams, p. 450, with reference
 to fresco of St Peter in church of Llanbadarn
 Fawr which resembled in style & color that of
 "St. Werburgh, found under a mass of whitewash,
 and lately restored to the church of that name
 in the city of Chester."

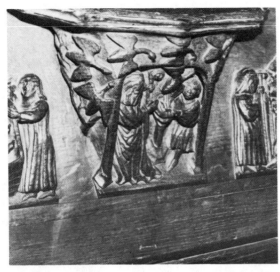

33. St Werburgh Restoring Goose to Life. Chester Cathedral Misericord N19.

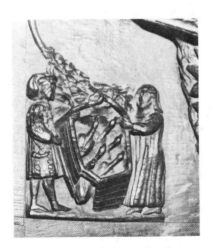

34. St Werburgh Enclosing Geese. Chester Cathedral Misericord N19 (L Supporter).

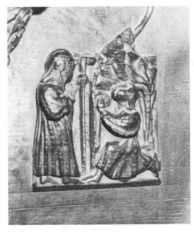

35. St Werburgh with Thief. Chester Cathedral Misericord N19 (R Supporter).

XI. MISCELLANEOUS

This section is very selective, with subheadings to related subjects. No attempt has been made to list all grotesques.

BESTIARY

Dragon

ChrCathC wdcarv, S choir stalls, corbel (S24). c.1380. Dragon (representing devil) eating man.

Pelican

ChrCathC wdcarv, N choir stalls, misericord (N24). c.1380. Pelican plucking at breast to feed her young.

wdcarv, N choir stalls, benchend (N18). c.1380. Pelican in her piety repeated on mouldings. Il Barber, "The Stalls," facing p. 50.

wdcarv, S choir stalls, misericord supporters (S11). c.1380. Pelican in her piety on L & R supporters to misericord of BVM & Child (see p. 30, above).

ChrCathCl-N rb, N cloister vaulting. Early 16c? (cloister built 1525-38). Pelican in her piety. Il Barber, "The Cloisters," Pl. facing p. 10.

Tiger

ChrCathC wdcarv, N choir stalls, misericord (N4). c.1380. Knight leaning backwards on galloping horse holds stolen tiger cub on lap & drops glass ball behind with R hand. Knight wears conical bascinet, camail, plate armor, spurs & sollerets. Tigress on L supporter picks up ball with her teeth. Tigress crouching on R supporter. Il Bennett, *The Choir Stalls*, p. 15. (Tigress is deceived by her own reflection in glass ball, & loses her cub because she stops to pick up the ball.) See fig. 36, below.

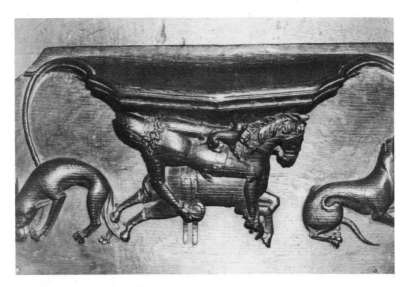

36. Tiger Hunt. Chester Cathedral Misericord N4.

Unicorn

ChrCathC wdcarv, S choir stalls, misericord (S17).
 Unicorn sits with head on lap of virgin in round-

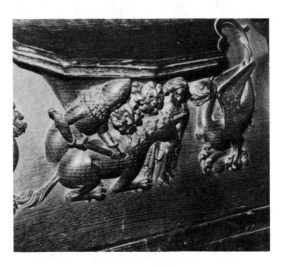

37. Slaying of the Unicorn. Chester Cathedral Misericord
S17.

necked gown to L. Knight in plate armor with
conical bascinet & camail covering over neck &
shoulders sinks lance(?) into its side. Wyvern
supporters.

DEADLY SINS

ChrCathC wdcarv, S choir stalls, corbel (S29). c.1380.
 Glutton eating haunch. Il Bennett, *The Choir
 Stalls*, p. 12.

ENTERTAINMENT

Green Man Mask

ChrCathC wdcarv, S choir stalls, benchend poppy head (S9).
 c.1380. Green man mask with foliage coming
 from mouth.

 wdcarv, S choir stalls, misericord supporters
 (S10). c.1380. L & R supporters to misericord
 with quarrelling couple (see p. 70): mask with
 foliage coming from mouth.

 wdcarv, S choir stalls, misericord (S3). c.1380.
 Mask with foliage coming from mouth. Smaller
 masks on supporters.

ChrCathCl-N rb, N cloister vaulting. Early 16c? (cloister
 built 1525-38). Bearded face with vine leaves
 surrounding head & foliage coming from mouth.
 Il Barber, "The Cloisters," Pl. facing p. 10, &
 tentatively identified as "Head of our Lord" re-
 presenting "I am the Vine."

Tumbler

ChrCathC wdcarv, N choir stalls, corbel (N9). c.1380.
 Male tumbler.

Wild Man (Wodehouse)

ChrCathC wdcarv, N choir stalls, benchend spandrel (N15).
 c.1380. Bearded wild man with 2 lions.

 wdcarv, N choir stalls, corbel (N30). c.1380.
 Wild man & dragon.

wdcarv, N choir stalls, misericord (N2). c.1380.
Barefooted wild man with club in L hand sitting
on lion with chain around its neck. Head oblit-
erated.

wdcarv, N choir stalls, misericord (N5). c.1380.
Bearded wild man with fur-covered body seated on
prostrate figure. Wild men on supporters.

wdcarv, S choir stalls, corbel (S47). c.1380.
Wild man & griffin.

wdcarv, S choir stalls, misericord (S12).
c.1380. Bearded wild man seated on lion with
chain around its neck. One end of chain held by
wild man in L hand. Supporters, 2 lions.

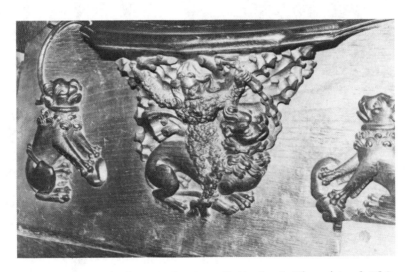

38. Wild Man on Lion. Chester Cathedral Misericord S12.

ChrCathC wdcarv, S choir stalls, misericord supporters
(S5). c.1380. Wild man on animal. Main subject
of misericord: lion & dragon fighting.

Wrestlers

ChrCathC wdcarv, S choir stalls, misericord (S16).
c.1380. Wrestlers center with marshals on either
side holding batons. Spectators looking through
trees in background. Angel supporters (see pp.

21-22, above).

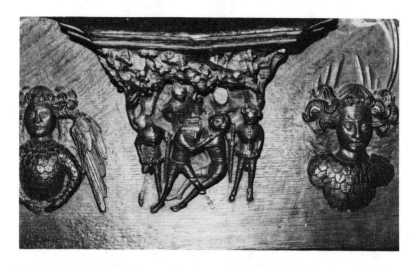

39. Wrestling Match. Chester Cathedral Misericord S16.

Fighting Couples

ChrCathC wdcarv, N choir stalls, misericord (N12).
 c.1380. Woman with R arm raised, holding some
 implement in R hand, & grasping man on his knees
 to her L by the tippet of his hood. Woman wears
 pointed shoes & full-skirted gown with fitted
 sleeves & buttoned round-necked bodice. Man
 wears hood, tunic with bag sleeves, & pointed
 shoes. See fig. 40, below.

 wdcarv, S choir stalls, misericord (S10).
 c.1380. Man (L) & woman (R) seated, leaning away
 from each other with arms akimbo. Green man mask
 supporters.

LAY FIGURES

Kings

ChrCath panel paintings* in arches of pulpitum (removed
 during Scott restoration, 1868-70). 16c. Kings
 of England from Conquest to Henry VII. See Wild,
 Illustration, p. 6.

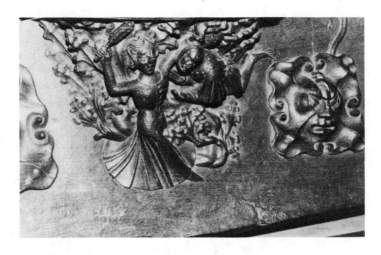

40. Fighting Couple. Chester Cathedral Misericord N12.

Knights

ChrCathC wdcarv, N choir stalls, misericord (N23).
 c.1380. Knight mounted on horse carrying lance
 with braided & tasselled cord over his L shoul-
 der, shield with St Andrew's cross over R.
 Knight wears conical bascinet & plate armor.
 Mistakenly identified as St Geo by Wolfgang, p.
 81.

StJ sc, tomb effigy on floor of N aisle of nave, W
 end. Original position unknown; dug up in
 churchyard before Ormerod's time. c.1320-30
 (Crossley, "Mediaeval Monumental Effigies,"
 c.1270-90, but compare effigies with similar
 gauntlets c.1320-30 cited by Blair, p. 134).
 Broken coal-measure sandstone effigy of unknown
 knight, legs & surcoat gone below knees, fig bro-
 ken into 3 pieces (at waist & hips), R forearm &
 hand almost totally missing. Head rests on 2
 rectangular cushions; L hand on chest, R grasped
 sword-hilt. R leg crossed over L above knee.
 Mail coif on head, with section of steel cap be-
 low coif visible over forehead. Dressed in mail
 hauberk with tight sleeves (no knee-cap or poleyn
 visible), sleeveless surcoat with wide armholes

& split skirt. No breastplate. Hands in plate
gauntlets with flaring cuffs above wrist ending
in blunt point on outside of arm. Sword hung
from belt passing loosely around hips & buckled
in front. Small convex shield held by strap o-
ver shoulder; shield rests on L upper arm. "It
is supposed to represent a Crusader of the Car-
rington family" (Ormerod, I, 323).

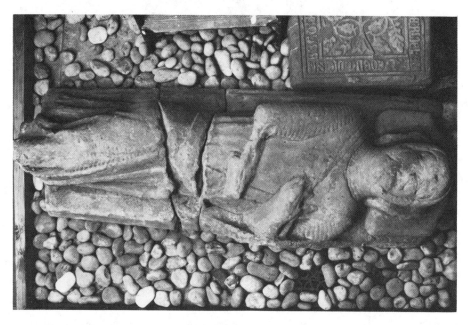

41. Knight. Effigy in nave of St John's Church.

HT sc*, tomb effigy, location unknown (probably be-
 neath floor). Originally in Lady Chapel on S
 side of church chancel (BL MS Harley 2151, f.
 117ᵛ); found buried 30 May 1853 in vault near E
 door under pew of Dr W. M. Thackeray; reburied
 by 1914; moved to floor of church by 1923 oppo-
 site S door with tablet above bearing inscription
 translated; reburied? c.1380. Mutilated ala-
 baster knight formerly on top of altar-tomb en-
 closed by railings. Head protected by conical
 bascinet decorated with flat band ornamented with
 roses & resting on helmet. Camail covering for
 neck & shoulders; plate armor on body; laminated
 plates on shoulders & forearms (vambraces);

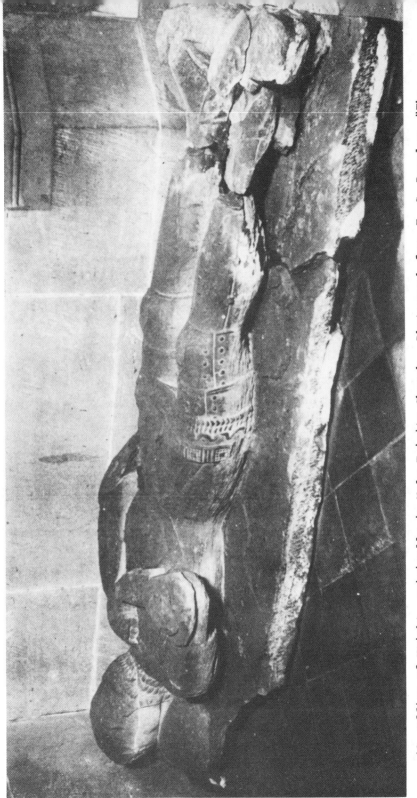

42. Effigy of Knight, originally in Holy Trinity Church. Photograph from F. C. Beazley, "The Parish of Thurstaston," Pl. facing p. 47.

shoulders & elbow joints protected by ornamental
circular caps. Hands bare. Legs in studded
plate, pointed shoes (sollerets) made of lami-
nated pieces of steel, also studded, & rowell
spurs buckled over. Jupon worn over shirt of
mail. Baudric across loins from which sword
hangs on L side. Shield on L side held by
strap over R shoulder. Shield & jupon bear Whit-
more arms, originally colored, the field vert,
the fretty topaz. Legs uncrossed, feet rest on
lion couchant, hands clasped in prayer. Broken
at ankles. Inscription reads: "Hic iacet Jo-
hannes de Whitmore obiit Kal. Octob. A.D. 1374"
(Lombardic caps around edge of slab). Il BL MS
Harley 2151, f. 117v; description & photograph
(see fig. 42) from Beazley.

Lawyer

StP brass, nailed to SE pillar of tower. Not *in
situ*. c.1460 (hat similar to that on brass of
lawyer John Edward, Rodmarton, Glos, dated 1461;
see Druitt, p. 232). Much worn brass removed
from floor of S aisle in 1884. No inscription
or date. Common civilian dress of 15c: long
plain robe without girdle reaching to ankles
with fringe of fur on skirt edge & bag sleeves.
Narrow pointed shoes. Distinctive hat with very
full high crown & turned-up edging, probably fur.
No hair visible; hands joined in prayer. Il
line drawings: Simpson, *History*, Pl. facing p.
52; Thornely, *Monumental Brasses*, p. 48.

Man

ChrCathC wdcarv, S choir stalls, misericord (S13).
c.1380. Bearded man seated wearing round cap,
long tunic with elaborate scalloped tippets
extending from elbows. Fitted sleeves of under-
garment visible below elbows.

Pilgrim

ChrCathC wdcarv, S choir stalls, elbow of benchend (S18).
Seated pilgrim with beard wearing broad-brimmed
hat with full crown, hood, short cloak, tunic, &
boots.

43. Pilgrim. Chester Cathedral Choir, benchend.

Women

StJ sc, tomb effigy on floor of N aisle of nave, W
 end. Original position unknown. c.1340. Muti-
 lated coal-measure sandstone semi-effigy; L side
 of head broken off. Lower part of slab deco-
 rated with foliage, border with inscription
 (Alice de Ridleigh, 1347). Hands clasped in
 prayer. Lady wears gown with round scooped
 neckline, sleeves ending at elbow with long
 tippets extending below. Round-necked kirtle
 underneath. Covrechef visible on head. Il
 Crossley, "Mediaeval Monumental Effigies," Pl.
 facing p. 7.

ChrCathC wdcarv, N choir stalls, L arm-rest of seat with
 misericord of Alexander's flight (N9). c.1380.
 Head & shoulders of woman with full sleeved
 gown, horned head-dress.

 wdcarv, S choir stalls, benchend (S14). c.1380.
 Woman holding open book in her lap wears long

gown with loose sleeves, mantle fastened at neck,
& covrechef falling upon shoulders.

RELIGIOUS ORDERS

Priest

StJ sc, tomb effigy on floor of N aisle of nave, W
end. Original position unknown. c.1330-40.
Worn coal-measure sandstone effigy of unknown
priest with raised border of ornamental foliage
around edge of slab. Head rests on small rec-
tangular pillow, hands clasped in prayer, legs
straight, feet on unidentifiable couchant animal.
Wearing ankle-length alb with close-fitting
wrist-length sleeves; plain chasuble on top,
hanging below knees with wide circular opening
for neck & broad upstanding collar. Bare head
with small tonsure. Face, hands, & feet badly
worn.

REYNARD THE FOX

ChrCathC wdcarv, N choir stalls, misericord (N11).
c.1380. Fox on its back with tongue out as if
dead. 3 birds pecking at its tongue & stomach.
Trees surrounding with 3 birds in branches; at
roots, fox disappears into hole with bird while
3 more foxes peep from another hole. On R sup-
porter fox devours bird; on L, lion asleep under
tree. Il Varty, Pl. 155; Wolfgang, Pl. facing
p. 85. Allegorical scene with fox representing
wily devil, birds the unwitting sinner. Varty
explains sleeping lion thus: "the Bestiary lion
symbolized vigilance. Since this lion may be
sleeping, it is possible that the carver merely
aimed to show what can happen if one is not vig-
ilant. Then again, the lion could represent
Christ, so the carver may have meant to remind
the onlooker that even if the evil-doer (the
fox) did seem to get away with his misdeeds
now, he eventually had to answer for them before
Christ" (p. 93).

wdcarv, N choir stalls, corbels (N15, 16).
c.1380. Fox & goose on R corbel (N15), woman
with animal on L (N16).

ChrCathC wdcarv, S choir stalls, misericord (S6). c.1380.
 Fox in friar's cloak on L receives blessing from
 superior (nun?) in hooded cloak on R. Two ap-
 parently female figs watching on either side a-
 mong trees.

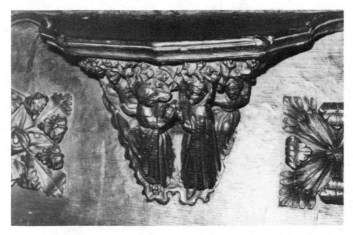

44. Fox friar. Chester Cathedral Misericord S6.

ROMANCE

Alexander

ChrCathC wdcarv, N choir stalls, misericord (N9). c.1380.
 Alexander, bearded & crowned in regal robe & er-
 mine tippet, sits with a griffin to L & R. Grif-
 fins also on supporters. Illustrates legend of
 Alexander's attempt to view the extent of the
 world after reaching its end. Griffins harnessed
 to his seat flew aloft with Alexander in their
 effort to reach meat at end of 2 spears fixed to
 seat. See fig. 45, below.

Sir Yvain

ChrCathC wdcarv, S choir stalls, misericord (S22). c.1380.
 Fortified gate of castle with portcullis fallen
 on back of horse; the rider (Sir Yvain) has es-
 caped. See fig. 46, below.

78

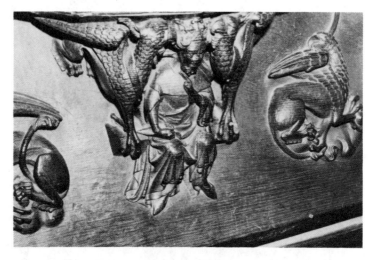

45. Alexander and Griffins. Chester Cathedral Misericord N9.

46. Sir Yvain's Horse Caught by Portcullis. Chester Cathedral Misericord S22.

Tristram and Iseult

ChrCathC wdcarv, N choir stalls, misericord (N6). c.1380.
 Short-haired young man in jupon, girdle, hose, &

shoes with ankle straps presents ring to young
woman in crown & gown with fitted sleeves, high
neck, & full skirt. Pet dog laps water at her
feet & bearded face with crown (King Mark) peers
through foliage behind lovers. L supporter:
older man, similarly dressed to young man, with
sword & shield under R arm. R supporter: older
woman holding small dog in R hand & wearing caul
& gown with long tippets extending from elbows,
kirtle visible beneath.

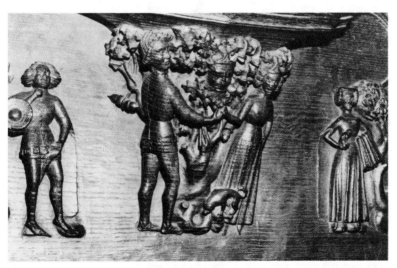

47. Tristram and Iseult. Chester Cathedral Misericord
N6.

LITURGICAL

StM-H pg, Troutbeck Chapel, Win S2Tr [A2], not *in situ*.
 15c. Gold chalice & rayed host inscribed IHS.

APPENDIX I

CULT AND SHRINE OF ST. WERBURGH

The earliest known authorities for the life of St. Werburgh
are Goscelin's *Vita S. Werburgae*[1] and Florence of Worcester's
Chronicon ex Chronicis.[2] Both accounts were written within a
few years of each other, in the late eleventh or early twelfth
century, and may have been based on a common Old English source
or sources.[3] From these early sources we know that St. Werburgh
was the daughter of Wulfhere, king of Mercia (658-75) and St.
Ermengild of Kent. She took the veil at the Benedictine abbey
of Ely under the direction of her great-aunt Etheldreda and was
joined there by her mother Ermengild after her father's death.
Werburgh demonstrated a holiness and humility which led her fa-
ther's successor Aethelred to appoint her head ("principatum")
of the chief nunneries in his kingdom. Florence names two of
these nunneries--Hanbury (Staffs.) and Trickingham (Threcking-
ham, Lincs.)--and Goscelin adds a third, Weedon (Northants.).[4]

A number of miracles were attributed to Werburgh by later
writers, but by far the best known was her taming of the wild
geese at Weedon, the legendary source for the misericord in the
subject list (see pp. 63ff). A lively version of the story is
included by Bradshaw in his *Holy Lyfe and History of Saynt Wer-
burge*:[5] a multitude of wild geese descended upon the lands of
Weedon abbey devouring crops and causing tenants to complain to
Werburgh. In response to their plea, she commanded a servant to
drive the geese from the fields and pen them at her house as
punishment. The servant was reluctant to obey what seemed to be
an unreasonable order, but after further words of encouragement,
he followed instructions and miraculously succeeded in driving
the birds, with wings trailing, into a pen. The next day, the
repentant geese were freed on condition that they never return
to Weedon. A servant had hidden one of the geese, however, and
when the flock realized that one of their number was missing,
they flew back to Werburgh to bid for the release of their fel-
low. The missing goose was then restored to the flock and they
flew away, never to devastate the lands of Werburgh again.[6]

Werburgh died at Trickingham on February 3, but the year is
not recorded by Goscelin or Florence. Chester tradition assigns
her death to 690,[7] although Goscelin's story of her translation
from grave to shrine nine years after burial by her cousin, King
Ceolred of Mercia (709-16), suggests a decease date between 700
and 707. Werburgh was buried, at her request, at Hanbury, where
her body remained uncorrupt for 200 years until the Danish inva-

sion of England.

Ranulph Higden picks up the tale at this point and elaborates further in his fourteenth-century *Polychronicon*, which records the flight of the citizens of Hanbury with the shrine and the now crumbled remains of the saint to a safer location at Chester.[8] According to local tradition used by Bradshaw, the original mother church of Chester dedicated to St. Peter and St. Paul was enlarged in the early tenth century by Aethelflaed, "Lady of the Mercians," in honor of St. Werburgh whose relics were there enshrined. This church of secular canons then became the Benedictine abbey of St. Werburgh in the late eleventh century. Bradshaw credits a number of miracles to the saint after her translation to Chester. The fourteenth-century shrine survives although it was heavily damaged during or shortly after the Dissolution and imperfectly restored in 1748. The shrine featured around its upper section thirty-four carved figures of kings and saints of Anglo-Saxon England (many related to Werburgh), holding scrolls on which were inscribed their names in Latin. The figures were supposed to have been of gold originally, but in the sixteenth century they were replaced by wooden ones with gold heads. Wooden heads replaced the gold ones after the Puritan destruction, but there was some mismatching of male and female heads and bodies. Although the inscriptions are worn away and the figures can no longer be identified with confidence, the following names were included by J. H. Hanshall (p. 222) in his nineteenth-century list of the figures on the shrine, beginning with the figure at the SW angle, fronting W, moving along the N front and round the E end (the shrine in his time was in the S choir):

1 Creoda, founder of the Mercian kingdom

2 Penda, king of Mercia, grandson of Creoda

3 Wulfhere, second son of Penda, father of St. Werburgh

4 Ceolred, nephew of Wulfhere, son of Aethelred (cousin of Werburgh)

5 ***

6 Offa, king of Mercia

7 Egbert, son of Offa, king of Mercia

8 ***

9 St. Kenelm (Cynhelm), king of Mercia

10 St. Mildburgh, daughter of Merewald, son of Penda

11 Beorn, king of East Angles

12 Ceolwulf, king of Mercia, uncle of St. Kenelm

13 ***

14 St. Eormenhild [Ermengild], mother of St. Werburgh, daughter of Erconbert, king of Kent, and St. Sexburgh

15 ***

16 Aethelred, king of Mercia, paternal uncle of St. Werburgh

17 St. Cyneburgh, paternal aunt of St. Werburgh, wife of Alcfrith, king of Northumbria

18 Coenred, brother of St. Werburgh

19 ***

20 Baldred, governor of Kent under Kenulf

21 Merewald, uncle of St. Werburgh, fourth son of Penda

22 Wiglaf, king of Mercia

23 Beorhtwulf, brother of Wiglaf, king of Mercia

24 Burhred, king of Mercia

25 ***

26 St. Etheldreda (Aethelthryth), great aunt of St. Werburgh

27 ***

28 ***

29 Aethelbert, king of Kent, great grandfather of St. Werburgh

30 St. Mildthryth, daughter of Merewald, cousin of St. Werburgh

Four other figures had been entirely cut away, two at the W end and two at the E end, when this list was made.

In 1536, the commissioners' report on the relics in Chester contained the final notice of Werburgh's cult at the abbey: "Here is buried the body of St. Werburga, and they have the girdle of that saint, in great request by lying-in women."[9]

NOTES

[1]Horstmann, *Life*, pp. xix-xxvi, includes Goscelin's *Vita* in his analysis of Bradshaw's sixteenth-century poem in Werburgh's honor.

[2]*Chronicon ex Chronicis*, ed. Thorpe, I, 32.

[3]See Tait, pp. viii-xiv, for a fuller account of the relationship between the Goscelin and Florence versions of Werburgh's life.

[4]Bradshaw, p. 122, included Repton (Derbys.) in his list on no certain authority. He also identified Trickingham (Threckingham) with Trentham, Staffs., but see Tait, pp. x-xi, for opposing arguments.

[5]Bradshaw, pp. 97-100. Goscelin's *Vita* has the earliest account of the miracle of the geese.

[6]Bradshaw (p. 99) also mentions a legend, attributed to William of Malmesbury, that the stolen goose was roasted and eaten the night before the flock returned, begging for its release. When Werburgh demanded the bird from her wayward servant, she was presented with the bones left over from the feast and therefore had to restore the goose to life as well as to its flock.

[7]*Annales Cestrienses*, ed. Richard Copley Christie, Lancashire and Cheshire Record Society, 14 (London: Record Society, 1887), p. 10.

[8]*Polychronicon*, ed. Lumby, VI, 126, 128, 366, under the year 875. Tait, p. xiv, suggests another possibility, that the relics were transferred after the acquisition of Hanbury by the church at Chester.

[9]*Letters and Papers, Foreign and Domestic, of the Reign of*

Henry VIII, arranged and catalogued by James Gairdner, X (London: HMSO, 1887), 141.

APPENDIX II

MUSICAL INSTRUMENTS IN SURVIVING CHESTER ART

Relatively few musical subjects survive in Chester from
the medieval period, although we know from civic and guild re-
cords and from the Chester cycle that musical performance was
an important aspect of the city's entertainment. The plays of
the Chester cycle, in fact, have a higher percentage of music
than other cycles extant, and approximately two-thirds of the
pageants have specific directions for singing or instrumental
music.[1] Surviving guild accounts for individual pageants tes-
tify, by their payments to minstrels and singers, that music
must have been featured more often even than the rubrics of the
play-texts suggest.[2]

Angelic vocal and instrumental music was used most often
dramatically, to symbolize heaven and to indicate the "presence,
power, and glory of God."[3] No specific instruments for angels
are mentioned in the plays or the guild records, although tradi-
tionally string instruments such as the harp, lute, and psaltery
were associated with the symbolic depiction of celestial harmo-
ny. The organ was also favored as the noblest accompaniment for
heavenly choirs. Extant medieval art in Chester parallels the
drama in its predilection for angel musicians. Predictably,
string instruments are dominant in misericords or corbels in the
Cathedral choir where angel music is an appropriate subject for
treatment. The satiric hand of the woodcarver never rested for
long, however; two corbels which resemble angels playing the
harp and lute at first glance, are revealed upon closer inspec-
tion as grotesque frauds with human heads and clawed feet.[4]

The most interesting example in this category, however, is
clearly on the west front of the Cathedral where angel musicians
accompany the Assumption of the Virgin. A small ensemble of
five angels playing a variety of wind and string instruments is
carved on one panel, although deterioration of the sandstone
prevents positive identification in a couple of cases. Twelve
angel singers in procession on other panels are given tradition-
al iconographical support by angels at two positive organs, to
fill out a picture of celestial celebration on a lavish scale.
This carving was contemporaneous with known performances of the
pageant of the Assumption by the wives of Chester, as discussed
elsewhere (see p. 4). Representations of angel musicians as
well as of the Assumption itself were popular in art of the la-
ter Middle Ages, so there can be no definite proof of influence
between the pageant and the west front carvings. Yet the choice

of instruments (none of them fabulous) and the presence of angel choristers may be legitimate indications of the type of music which must have been a key part of the wives' pageant, the only play whose text is lost from the cycle.[5]

A number of instruments are mentioned in the banns, pageants, or accounts of the Chester cycle--the beam, flute, horn, pipe, tabard, and regals--but the representations of wind instruments in musical iconography are restricted to shawms and a serpent, and the only percussion is on an isolated corbel (S36) of a man beating a drum in the Cathedral choir.

Identification of instruments on early wood or stone carvings is necessarily tentative. Details were not always given precisely by the artists and damage by time or human hand can render a carved instrument unrecognizable. Certainly any attempt to classify a shawm as treble, tenor, or bass in a generalized artistic rendition, with its inevitable distortions of size, is overly optimistic. Even distinguishing between a citole and a mandore can be treacherous because the necessary perspective for recognizing a flat or round-backed instrument may be lacking on a small medieval carving. With these provisos in mind, the following list of musical subjects in surviving Chester art is made:

String Instruments

Citole

ChrCathC wdcarv, N choir stalls, misericord (N8), angel playing citole(?) with plectrum.

 wdcarv, S choir stalls, misericord (S24), angel playing citole(?) with plectrum on L & R supporters.

Harp

ChrCathC wdcarv, archdeacon of Macclesfield's stall, benchend (N3). David on benchend moulding carries harp.

 wdcarv, N choir stalls, corbel (N19). Grotesque with man's head and clawed feet holds harp.

 wdcarv, N choir stalls, corbel (N18), angel holding harp (damaged).

ChrCathWF stone carving, on panel above W door, angel hold-
ing harp.

Lute

ChrCathC wdcarv, N choir stalls, corbel (N5), angel play-
ing lute.

wdcarv, S choir stalls, corbel (S3). Grotesque
with man's head & clawed feet playing lute. Up-
per section broken off.

ChrCathWF stone carving, on panel above W door, angel hold-
ing broken stringed instrument, possibly lute.

Wind Instruments

Serpent

ChrCathWF stone carving, panel above W door, angel with long,
curved instrument (serpent?) or scroll.

Shawm

ChrCathWF stone carving, panel above W door, angel playing
shawm.

StM-H wdcarv, pulpit panel, location now unknown, 2 an-
gels blowing shawms.

Transverse Flute

ChrCathWF stone carving, panel above W door, angel holding
instrument with both hands--transverse flute?

Percussion Instruments

Drum

ChrCathC wdcarv, S choir stalls, corbel (S36). Man beat-
ing drum.

Organs

ChrCathWF stone carving, above W door to L & R (edges) of
panel with angel musicians, angel playing posi-
tive organ with another angel assisting on bel-

PLATE I

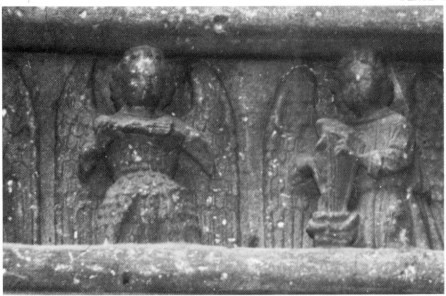

Angel Musicians on West Front, Chester Cathedral. Part of an Assumption group (see pp. 46-47). Angel at right plays harp; at left is angel holding instrument with both hands.

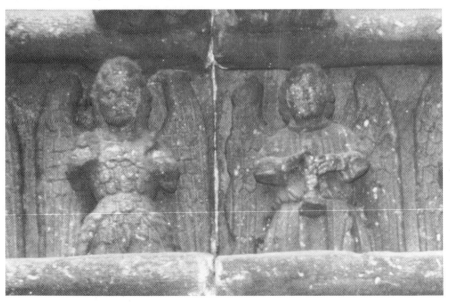

Angel Musicians on West Front, Chester Cathedral; also part of Assumption group. Instrument formerly held by angel at left is broken away, while angel at right holds shawm.

PLATE II

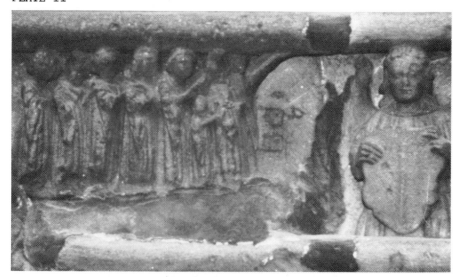

Procession of Angels in albs on West Front, Chester Cathedral.
Part of Assumption group. At right, angel holding shield.

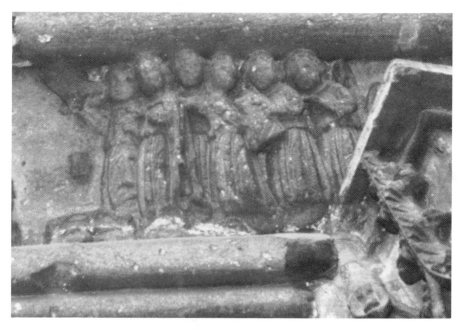

Another Procession of Angels in albs on West Front, Chester
Cathedral. Part of Assumption group.

lows.

Singers

ChrCathWF stone carving, above doorway to L & R of panel
with angel musicians, 6 angels on either side
singing in procession toward center.

NOTES

[1]See Carpenter and Dutka for more precise details on the
instruments and music used in individual pageants.

[2]See Clopper, *Chester, passim*, pageant accounts of Cord-
wainers and Shoemakers; Painters, Glaziers, Embroiderers, and
Stationers; and especially Smiths, Cutlers, and Plumbers who
itemize many payments for music although no musical directions
are given in their play of the *Purification* and *Christ and the
Doctors*.

[3]Carpenter, p. 197.

[4]The grotesque on corbel S3 is identified as "angel play-
ing lute" in Bennett's guide, *The Choir Stalls*, p. 10.

[5]The size of the angel chorus should not, perhaps, be taken
at face value. The two panels, each with six singers and ac-
companying organ, may be examples of symmetrical duplication
often found in fourteenth- and fifteenth-century pictorial de-
pictions of the Assumption and Coronation. See Winternitz, pp.
39-40.

APPENDIX III

LIST OF CHESTER CATHEDRAL MISERICORDS

The misericords in the choir stalls of Chester Cathedral
are the richest survivals of medieval narrative art in the city.
All misericords with biblical subjects have been listed in the
main body of the text, as well as other carvings, in the mis-
cellaneous category, which are of tangential interest, either
for their representation of period costume or for their depic-
tions of scenes such as the fighting couple (see 13, below)
which has an obvious parallel in dramatic rendering of Noah and
his termagant wife. A detailed description of all the miseri-
cords of the Cathedral was published by Dean Howson at the time
of Scott's restoration and is provided below from Howson's *Hand-
book to Chester Cathedral*, 2nd ed. (Chester: Phillipson and
Golder, 1882), pp. 63-65. Cross references have been provided
for subjects described elsewhere and--occasionally--identified
differently.

North Side (West to East)

1. A pelican feeding her young [see p. 66, above]

2. A knight in full armour, on horseback: his lance over the
 left shoulder, and shield charged with a St. Andrew's cross
 over the right: the carving of the armour is very fine and
 appears to be of the time of Richard II [see p. 71, above]

3. Seraphs holding emblems of the Passion: oak leaf pattern
 terminating the mouldings [see pp. 19-20, above]

4. A griffin: thorn leaf pattern terminating the mouldings

5.

6. Scene from the legend of St. Werburgh: In the centre the
 story of the restored goose; on one side the culprit de-
 tected, on the other the culprit confessing [see pp. 63-64]

7. Modern, by Mr. Armitage: the fox and the grapes, with
 foliage

8. Modern, by Mr. Armitage: The fox and the crow, with grif-
 fins as supporters

9. Modern, by Mr. Bridgman: Angels removing the stone from

the Saviour's tomb; soldiers sleeping below; on one side
the gardener, on the other Mary Magdalene

10. Modern, by Mr. Armitage: The fox and the stork; supporters
 griffins, ending in foliage

11. A mask: two of smaller size as supporters

12. A griffin and a hog fighting: goats on supporters, one of
 them scratching its neck with its hind leg, the other in a
 quiet attitude

13. A wife with husband on his knees at her feet, with one hand
 holding him by the tippet of his hood, with the other chas-
 tising him with some domestic implement. The costume should
 be noted [see pp. 70-71, above]

14. A forest scene: a fox on his back, with tongue out, as if
 dead: birds pecking at his tongue and on his legs: the
 supporters, on one side a fox carrying off a duck, on the
 other a lion startled by the sound of birds. The trees are
 oak and black elder: at the roots are rabbits at the en-
 trance of their burrows [see p. 76, above]

15. Two herons, one walking, the other standing with head set
 back: one supporter a figure with man's head and heron's
 body, the other a dragon

16. Seated figure of a king, richly draped: on each side of him
 a griffin with one fore-leg on the seat, as if guarding [see
 pp. 77-78, above]

17. An angel, richly draped and seated, playing a cithara: the
 supporters, angels in the clouds [see pp. 19-20, above]

18. Monster with head and forelegs of lion and two dragons'
 bodies: supporters, two heads

19. A young man presenting a ring to a young woman who is
 crowned, a pet dog at her feet: a crowned head, with long
 beard, looks down upon them through the foliage: right sup-
 porter, an aged man with sword under his arm: left, an aged
 woman, with pet dog in one hand [see pp. 78-79, above]

20. A wild man, or man draped in animal's skin, seated on a
 prostrate man: the supporters are also hairy figures, one
 in violent action, the other seated on a tree [see p. 69]

21. A knight in armour, on horseback, leaning backward: two bloodhounds supporters [see pp. 66-67]

22. Grotesque animal with lion's head and bat's wings: the supporters are a double fleur-de-lys

23. A wild man, with club, bestriding a lion with a chain about its neck: supporters, hybrid animals [see p. 69, above]

24. A stag-hunt; as supporter on the right a hound chasing a stag; in the centre a knight with a bow, a servant leading a hound in leash; trees round them with birds; left hand supporter, a squire bringing up the horse at full gallop

South Side (East to West)

25. King's head crowned: supporters, two medallion heads with collars

26. Lion mask, supported by two of smaller size

27. Mask, with foliage growing out of the mouth: supporters two smaller masks [see p. 68, above]

28. Richard Coeur de Lion pulling the heart out of the lion, the keeper, with sword under his arm, looking on; supporters two gulls, to shew that the event happened across the sea [see p. 24, above]

29. Lion and dragon fighting: supporters, two wild men on animals, one quietly seated, the other struggling [see p. 69, above]

30. A Fox in costume of a monk making an offering to a nun; two nuns watching among the trees [see p. 77, above]

31. A winged figure rising from a shell, and fighting with dragons; supporters, on one side two figures, half human, half animal, in combat; on the other, a figure, half human, half animal, a deacon with stole over left shoulder, one hand holding a cock

32. Man's head on two animals' bodies; supporters two heads

33. A lion's head crowned on two bodies; two monsters as supporters

34. A man and woman seated, not amicably, side by side, foliage around [see p. 70, above]

35. Virgin and Child, an angel on each side; pelicans feeding their young from their breasts as supporters [see pp. 30, 66, above]

36. A wild man seated on a lion, with chain round his neck; supporters, two lions [see p. 69, above]

37. Figure of a man seated, richly draped, with round cap; supporters, two roses [see p. 74, above]

38. Sow and young pigs in a wood, a man looking through the branches at them

39. A man leading a lion with one hand, and holding a club in the other; two lions as supporters

40. Wrestlers: very interesting as shewing the manner in which wrestling was done in the period when these carvings were made; marshals on each side with their batons; spectators in the background looking through the trees [see pp. 69-70, above]

41. Unicorn, with its head on a virgin's knee; a knight attacking it [see pp. 67-68, above]

42. A head on two bodies, foliage supporting

43. A knight, fully armed, prostrate on his back; a griffin standing over him; two dogs supporters

44. Foliage, with roses

45. A falcon with a duck in its talons; supporters, two falcons

46. Gate with portcullis fallen on the back of the horse of a rider who escapes; supporters two heads [see pp. 77-78, above]

47. Grotesque animals

48. Coronation of the Virgin seated under a canopy; angels playing the citherne as supporters [see pp. 21, 48, above]

SELECTED BIBLIOGRAPHY

I. *Abbreviations*

ArchCamb	*Archaeologia Cambrensis*
ArchJ	*Archaeological Journal*
CompD	*Comparative Drama*
CsH	*Cheshire Historian*
CsS	*Cheshire Sheaf*
JCNWAAHS	*Journal of the Chester and North Wales Architectural, Archaeological, and Historic Society*
JWCI	*Journal of the Warburg and Courtauld Institutes*
PMLA	*Publications of the Modern Language Association*
TransHSLaCs	*Transactions of the Historic Society of Lancashire and Cheshire*
TrLaCsAnt	*Transactions of the Lancashire and Cheshire Antiquarian Society*

N.B.: One abbreviation has been used to refer to the *Journal of the Chester and North Wales Architectural, Archaeological, and Historic Society* which has appeared under a variety of titles since its inception in the mid-nineteenth century. The preferred title is the most common and is also the one used by standard reference works.

II. *Manuscripts*

Cheshire Monuments. Randle Holme MSS. BL MS. Harley 2151. 17c.

Holy Trinity Churchwardens' Accounts. Randle Holme MSS. BL MS. Harley 2177, fols. 20v-53. 17c.

Psalter and Masses. Bodleian Library MS. Tanner 169. 12c.

St. Mary-on-the-Hill Churchwardens' Accounts. Cheshire Record Office MS. P 20/13/1. 16-17c.

St. Michael Churchwardens' Accounts. Cheshire Record Office MS. P 65/8/1. 16-17c.

III. *Printed Works*

Addleshaw, G. W. O. *Chester Cathedral*. London: Pitkin Pictorials, 1975.

Anderson, M. D. *Drama and Imagery in English Medieval Churches*.

Cambridge: Cambridge Univ. Press, 1963.

Angus-Butterworth, L. M. "The Monumental Brasses of Cheshire," *TrLaCsAnt*, 55 (1940), 81-106.

Anon. "The Late Rev. W. H. Massie: The Society's First Ecclesiastical Secretary," *JCNWAAHS*, o.s. 1 (1849-55), 383-413.

Anon. "Proceedings of the Royal Archaeological Institute: The Summer Meeting at Chester," *ArchJ*, 94 (1937), 301-31.

Anon. "Report of the Sixty-third Annual Meeting, held at Chester, 16th to 20th August, 1909," *ArchCamb*, 6th ser., 10 (1910), 157-227.

Ayres, L. M. "A Tanner Manuscript in the Bodleian Library and Some Notes on English Painting of the Late Twelfth Century," *JWCI*, 32 (1969), 41-54.

B., J. "Randle Holme's Notes on Cheshire Churches," *CsS*, 3rd ser., 3 (February 1899), 17-19.

Barber, E. "The Nave Roof of the Church of St. Mary-on-the-Hill," *JCNWAAHS*, n.s. 8 (1902), 67-80.

_____. "The Cloisters of Chester Cathedral," *JCNWAAHS*, n.s. 9 (1903), 5-19.

_____. "Chester Cathedral: The Stalls, Misereres, and Woodwork of the Choir," *JCNWAAHS*, n.s. 9 (1903), 46-58.

_____. "The South Transept of Chester Cathedral," *JCNWAAHS*, n.s. 9 (1903), 99-114.

_____. "The Ancient Glass in the Church of St. Mary-on-the-Hill," *JCNWAAHS*, n.s. 10 (1904), 53-67.

_____. "The St. Oswald's Reredos; and the Frescoes in Chester Cathedral," *JCNWAAHS*, n.s. 15 (1909), 119-32.

_____. "The Painting in the South Aisle of the Church of St. Mary-on-the-Hill, Chester," *JCNWAAHS*, n.s. 17 (1911), 126-29.

_____. "Chester Cathedral: the Recent Work in the Cloisters and Refectory," *JCNWAAHS*, n.s. 21 (1915), 169-83.

Barraclough, Geoffrey, ed. *Facsimiles of Early Cheshire Charters*. Oxford: Basil Blackwell, 1957.

Beazley, F. C. "The Parish of Thurstaston," *TransHSLaCs*, 75 (1923), 1-177.

Bennett, Brian T. N. *The Choir Stalls of Chester Cathedral*, 2nd ed. Chester, 1968.

Bennett, Frank. *Chester Cathedral*. Chester: Phillipson and Golder, 1925.

Bennett, J. H. E. "The White Friars of Chester," *JCNWAAHS*, n.s. 31, Pt. 1 (1935), 5-54.

_____. "The Hospital and Chantry of St. Ursula the Virgin of Chester," *JCNWAAHS*, n.s. 32, Pt. 2 (1938), 98-129.

_____. "The Black Friars of Chester," *JCNWAAHS*, n.s. 39 (1952), 29-58.

Beresford, J. R. "The Churchwarden's Accounts of Holy Trinity, Chester, 1532 to 1633," *JCNWAAHS*, n.s. 38 (1951), 95-172.

Birch, W. de G. *Catalogue of Seals in the Department of Manuscripts in the British Museum*. London: William Clowes, 1887. Vol. I.

Blair, C. "The Pre-Reformation Effigies of Cheshire," *TrLaCsAnt*, 60 (1948), 117-44.

Blake, E. O., ed. *Liber Eliensis*. Camden Society, 3rd ser., 92. London: Royal Historical Society, 1962.

Blomfield, The Rev. Canon. "On the Lady Chapel in Chester Cathedral," *JCNWAAHS*, o.s. 2 (1855-62), 129-42.

Bond, Francis. *Wood Carvings in English Churches*. London: Oxford Univ. Press, 1910. 2 vols.

Bottomley, Frank. *The Church Explorer's Guide to Symbols and their Meaning*. London: Kaye and Ward, 1978.

Borenius, Tancred. *St. Thomas Becket in Art*. London: Methuen, 1932.

Bradshaw, Henry. *The Holy Lyfe and History of Saynt Werburge*

Very Frutefull for All Christen People to Rede, ed. Edward Hawkins. Remains Historical and Literary Connected with the Palatine Counties of Lancaster and Chester, 15. London: Chetham Society, 1848.

Brownbill, J. "A Chester Miracle," *CsS*, 3rd ser. 9 (May 1912), 47.

Burne, R. V. H. "The Falling Towers of S. John Baptist Church," *JCNWAAHS*, n.s. 36, Pt. 1 (1946), 5-20.

_____. "The Dissolution of St. Werburgh's Abbey," *JCNWAAHS*, n.s. 37, Pt. 1 (1948-49), 5-35.

_____. "The Founding of Chester Cathedral," *JCNWAAHS*, n.s. 37, Pt. 1 (1948-49), 37-67.

_____. "What Happened at the Reformation," *CsH*, No. 4 (1954), pp. 1-4.

_____. *Chester Cathedral from its Founding by Henry VIII to the Accession of Queen Victoria*. London: SPCK, 1958.

_____. *The Monks of Chester: The History of St. Werburgh's Abbey*. London: SPCK, 1962.

Caiger-Smith, A. *English Medieval Mural Paintings*. Oxford: Clarendon Press, 1963.

Carpenter, Nan Cooke. "Music in the Chester Plays," *Papers on English Language and Literature*, 1 (1965), 195-216.

Cave, C. J. P. *Roof Bosses in Medieval Churches*. Cambridge: Cambridge Univ. Press, 1948.

Christie, Richard Copley, ed. *Annales Cestrienses; or, Chronicle of the Abbey of S. Werburg, at Chester*. Record Society for the Publication of Original Documents relating to Lancashire and Cheshire, 14. London: Record Society, 1887.

Clopper, Lawrence M., ed. *Chester*. Records of Early English Drama. Toronto: Univ. of Toronto Press, 1979.

Collins, Fletcher, Jr. "Music in the Craft Cycles," *PMLA*, 47 (1932), 613-21.

Collins, Patrick J. "Narrative Bible Cycles in Medieval Art and

Drama," *CompD*, 9 (1975), 125-46.

Crossley, Fred H. "Stallwork in Cheshire," *TransHSLaCs*, n.s.
 32 (1917 [for 1916]), 85-106.

_____. "Mediaeval Monumental Effigies Remaining in Chesh-
 ire," *TransHSLaCs*, n.s. 40 (1925 [for 1924]), 1-51.

_____. *Chester Cathedral Refectory*. Chester, 1939.

_____. *English Church Craftsmanship*. London: B. T. Bats-
 ford, 1941.

_____. *Cheshire*. London: R. Hale, 1949.

Davidson, Clifford. *Drama and Art*. Kalamazoo: The Medieval In-
 stitute, 1977.

_____ and David E. O'Connor. *York Art*. Early Drama, Art,
 and Music Reference Series, 1. Kalamazoo: Medieval In-
 stitute Publications, 1978.

Didron, Adolphe Napoléon (and Margaret Stokes). *Christian Icon-
 ography*. 1851; rpt. New York: Ungar, 1965. 2 vols.

Dingley, Thomas. *History from Marble*. Camden Society, 97.
 London, 1868.

Druitt, Herbert. *A Manual of Costume as Illustrated by Monumen-
 tal Brasses*. London: The De La More Press, 1906.

Dugdale, W. *Monasticon Anglicanum*. London, 1655-73; new ed.
 with additions by John Caley, Henry Ellis, and Bulkeley
 Bandinel. London: Longman, Hurst, Rees, Orme, and Brown,
 1817-30. 6 vols. (in 8 parts).

Dutka, JoAnna. "Music and the English Mystery Plays," *CompD*, 7
 (1973), 135-49.

_____. *Music in the English Mystery Plays*. Early Drama,
 Art, and Music Reference Series, 2. Kalamazoo: Medieval
 Institute Publications, 1980.

Earwaker, J. P. "The Ancient Parish Books of the Church of St.
 Mary-on-the-Hill, Chester," *JCNWAAHS*, n.s. 2 (1888), 132-
 48.

_____. "Notes on the Registers and Churchwardens' Accounts of St. Michael's, Chester," *JCNWAAHS*, n.s. 3 (1890 [for 1888-89 and 1889-90]), 26-44.

_____. *The History of the Church and Parish of St. Mary-on-the-Hill, Chester*, ed. R. H. Morris. London: Love and Wyman, 1898.

Farrall, L. M. "Holy Trinity Church, Chester: Records of Three Centuries," *JCNWAAHS*, n.s. 21 (1914), 150-68.

Fenwick, George Lee. *A History of the Ancient City of Chester from the Earliest Times*. Chester: Phillipson and Golder, 1896.

Gardner, Arthur. *A Handbook of English Medieval Sculpture*. Cambridge: Cambridge Univ. Press, 1935.

_____. *English Medieval Sculpture*, revised ed. Cambridge: Cambridge Univ. Press, 1951.

Hanshall, J. H. *The History of the County Palatine of Cheshire*. Chester: J. Fletcher, 1817.

Harris, Brian. *Chester*. Bartholomew City Guides. London: John Bartholomew, 1979.

_____, ed. *A History of the County of Chester*. Victoria History of the Counties of England. Oxford: Oxford Univ. Press, 1980. Vol. II.

Hemingway, Joseph. *History of the City of Chester from Its Foundation to the Present Time*. Chester: J. Fletcher, 1831. 2 vols.

Hiatt, Charles. *The Cathedral Church of Chester: A Description of the Fabric and a Brief History of the Episcopal See*. London: G. Bell and Sons, 1911.

Horstmann, Carl, ed. *The Lives of the Women Saints of our Contrie of England*. Early English Text Society, o.s. 86. London, 1886.

_____. *The Life of Saint Werburge of Chester by Henry Bradshaw*. Early English Text Society, o.s. 88. London, 1887.

Howson, J. S. *Restoration of Chester Cathedral.* Chester: Min-
 shull and Hughes, 1874.

_____. *Handbook to Chester Cathedral*, 2nd ed. Chester:
 Phillipson and Golder, 1882.

Hughes, T. Cann. "The Misericords in Chester Cathedral,"
 JCNWAAHS, n.s. 5 (1893), 46-57.

Jones, Douglas. *The Church in Chester 1300-1540.* Manchester:
 Chetham Society, 1957.

Kendon, F. *Mural Paintings in English Churches During the Mid-
 dle Ages.* London: The Bodley Head, 1923.

Keswick, Harry. *The Church of St. John the Baptist, Chester:
 A Short Account of Its History and Architecture.* Chester,
 1886.

King, Richard John. *Handbook to the Cathedrals of England:
 Northern Division.* London: John Murray, 1869.

Le Couteur, J. D. *English Mediaeval Painted Glass.* London:
 SPCK, 1926.

Little, A. G., ed. *Franciscan History and Legend in English
 Mediaeval Art.* Manchester: Manchester Univ. Press, 1937.

Lumby, J. R., ed. *Polychronicon Ranulphi Higden Monachi Ces-
 trensis.* London: Longman, 1876. Vol. VI.

Lumiansky, R. M., and David Mills, eds. *The Chester Mystery
 Cycle*, I. Early English Text Society, s.s. 3. London:
 Oxford Univ. Press, 1974.

Lysons, Daniel, and Samuel Lysons. *Magna Britannia: being a
 Concise Topographical Account of the Several Counties of
 Great Britain.* London: T. Cadell and W. Davies, 1810.
 Vol. II, Pt. 2 (The County Palatine of Chester).

Macklin, Herbert W. *Monumental Brasses.* London: George Allen,
 1913.

Mathews, Godfrey W. "The Becket Boss in the Lady Chapel, Ches-
 ter Cathedral," *TransHSLaCs*, 86 (1935 [for 1934]), 41-46.

Milburn, R. L. P. *Saints and Their Emblems in English Churches.*

Oxford: Blackwell, 1957.

Montagu, Jeremy. *The World of Medieval and Renaissance Musical Instruments*. Woodstock, N.Y.: Overlook Press, 1976.

Morris, Richard. *Cathedrals and Abbeys of England and Wales: The Building Church, 600-1540*. London: Dent, 1979.

Morris, Rupert H. *Chester in the Plantagenet and Tudor Reigns*. Chester: G. R. Griffith, [1894?].

_____, ed. and completed by P. H. Lawson. *The Siege of Chester 1643-1646*. Chester, 1923.

Newstead, R. "Excavations on the Site of the New Telephone Exchange, St. John Street, Chester," *JCNWAAHS*, n.s. 32 (1939), 9-31.

Ormerod, George. *The History of the County Palatine and City of Chester . . . with a Republication of King's Vale Royal and Leycester's Cheshire Antiquities*. London: Lackington, 1819. 2nd ed. revised and enlarged by Thomas Helsby. London, [1875]-82. 3 vols.

Pächt, Otto, and J. J. G. Alexander. *Illuminated Manuscripts in the Bodleian Library, Oxford*. Vol. III: *British, Irish, and Icelandic Schools*. Oxford: Clarendon Press, 1973.

Parker, J. H. *The Medieval Architecture of Chester*. Chester: H. Roberts, 1858.

Pedrick, Gale. *Monastic Seals of the XIIIth Century*. London: De La More Press, 1902.

Pevsner, Nikolaus, and Edward Hubbard. *Cheshire*. Harmondsworth, 1971.

Phillips, John. *The Reformation of Images: Destruction of Art in England, 1535-1660*. Berkeley and Los Angeles: Univ. of California Press, 1973.

Raines, F. R., ed. *Notitia Cestriensis, or Historical Notices of the Diocese of Chester, by the Right Rev. Francis Gastrell. . . .* Manchester: Chetham Society, 1845. Vol. I: Cheshire.

Remnant, G. L. *A Catalogue of Misericords in Great Britain*.

Oxford: Clarendon Press, 1969.

Richards, Raymond. *Old Cheshire Churches: A Survey of their History, Fabric and Furniture with Records of the Older Monuments,* revised ed. Didsbury, Manchester: E. J. Morten, 1973.

Ridgway, Maurice H. "Coloured Window Glass in Cheshire: Part I--XIV Century," *TrLaCsAnt,* 59 (1947), 41-84.

_____. "Coloured Window Glass in Cheshire: Part II, 1400-1550," *TrLaCsAnt,* 60 (1948), 56-85.

"St. Nicholas' Chapel, Chester," *JCNWAAHS,* o.s. 2, Pt. 5 (1858 [for 1856-57]), 20.

Salter, F. M. *Mediaeval Drama in Chester.* Toronto: Univ. of Toronto Press, 1955.

Scott, George Gilbert. "On the Architectural History of Chester Cathedral, as Developed during the Present Work of Restoration," *JCNWAAHS,* o.s. 3 (1863-85), 159-82.

Scott, S. Cooper. *Lectures on the History of S. John Baptist Church and Parish, in the City of Chester.* Chester: Phillipson and Golder, 1892.

_____. *Guide to the Church of Saint John the Baptist, in the City of Chester.* Chester: Phillipson and Golder, 1899.

Simpson, Frank. *A History of the Church of St. Peter in Chester.* Chester: G. R. Griffith, 1909.

_____. "Chester Castle, A.D. 907-1925," *JCNWAAHS,* n.s. 26 (1924-25), 71-132.

Smith, William, and William Webb. *The Vale-Royall of England: Or, The County Palatine of Chester Illustrated.* London: Daniel King, 1656.

Stewart-Brown, R. "The Hospital of St. John at Chester," *TransHSLaCs,* n.s. 42 (1927 [for 1926]), 66-106.

_____, ed. *Cheshire in the Pipe Rolls 1158-1301.* Mabel H. Mills, transcr. (from 1237). Record Society for the Publication of Original Documents relating to Lancashire and Cheshire, 92. 1938.

Tait, James, ed. *The Chartulary of Register of the Abbey of St. Werburgh, Chester*. 2 pts. Remains Historical and Literary Connected with the Palatine Counties of Lancaster and Chester, n.s. 79, 82. Manchester: Chetham Society, 1920, 1923.

Taylor, F. "Selected Cheshire Seals (12th-17th Century) from the Collections in the John Rylands Library," *Bulletin of the John Rylands Library*, 26 (1941-42), 393-412.

Thornely, James L. *The Monumental Brasses of Lancashire and Cheshire, with Some Account of the Persons Represented*. 1893; rpt. Wakefield: EP Publishing, 1975.

Thorpe, Benjamin, ed. *Florentii Wigorniensis Monachi Chronicon ex Chronicis*. London: English Historical Society, 1848. Vol. I.

Varty, Kenneth. *Reynard the Fox: A Study of the Fox in Medieval English Art*. Leicester: Leicester Univ. Press, 1967.

Walcott, Mackenzie E. C. "Inventories of Church Goods and Chantries in Cheshire, Temp. Edward VI," *TransHSLaCs*, n.s. 11 (1870-71), 173-80.

Wild, Charles. *An Illustration of the Architecture of the Cathedral Church of Chester*. London: W. Bulmer, 1813.

Williams, J. G. "Llanbadarn Fawr Church, Cardiganshire," *ArchCamb*, 3rd ser., 14 (1868), 449-50.

Williams, Stephen W. "Effigy in Holy Trinity Church, Chester," *JCNWAAHS*, n.s. 6 (1899), 42-48.

Winternitz, Emanuel. *Musical Instruments and their Symbolism in Western Art*. London: Faber and Faber, 1967.

Wolfgang, A. "Misericords in Lancashire and Cheshire Churches," *TransHSLaCs*, 63 (1911), 79-87.

Wormald, Francis, ed. *English Benedictine Kalendars After A.D. 1100*. Vol. I: *Abbotsbury-Durham*. Henry Bradshaw Society, 77. London, 1939.

INDEX

114